PROPERTY OF

E. DRUM

Chris Hart

Figure It Out!

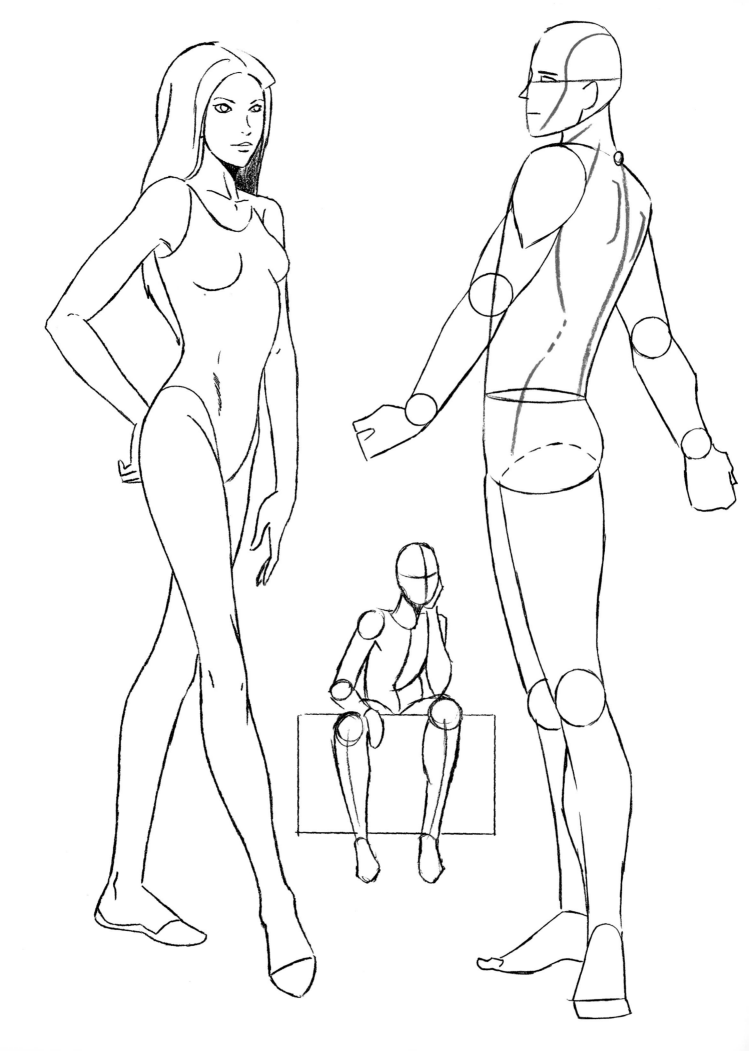

Chris Hart

Figure It Out!
The Beginner's Guide to Drawing People

Chris Hart Books

sixth&spring books

Chris Hart Books

An imprint of Sixth&Spring Books
161 Avenue of the Americas, 13th Floor
New York, NY 10013

Book Division Manager
WENDY WILLIAMS

Vice President, Publisher
TRISHA MALCOLM

Senior Editor
MICHELLE BREDESON

Production Manager
DAVID JOINNIDES

Art Director
DIANE LAMPHRON

Creative Director
JOE VIOR

Associate Art Director
SHEENA T. PAUL

President
ART JOINNIDES

Copy Editor
KRISTINA SIGLER

Book Design
CHRISTOPHER THOMPSON

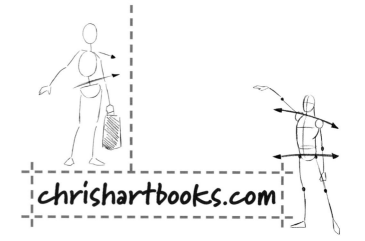

Library of Congress Control Number: 2008936330

ISBN-13: 978-1-933027-80-7
ISBN-10: 1-933027-80-0

Manufactured in China

14

First Edition

chrishartbooks.com

For illustrators, comic artists
and cartoonists everywhere.

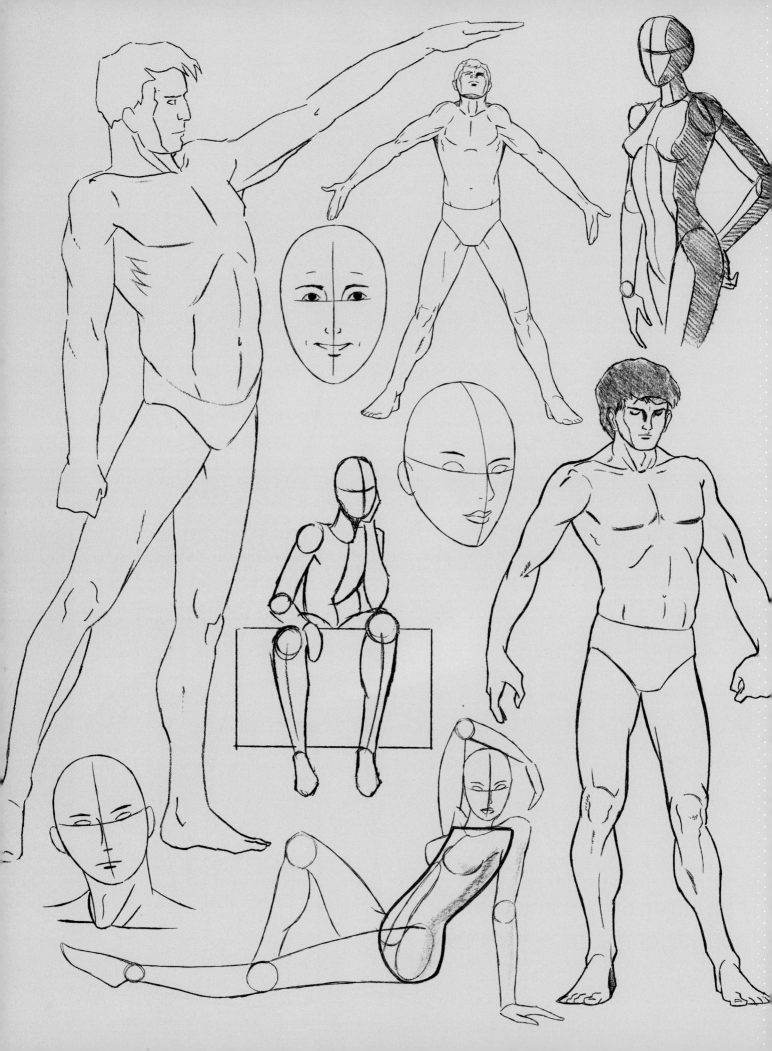

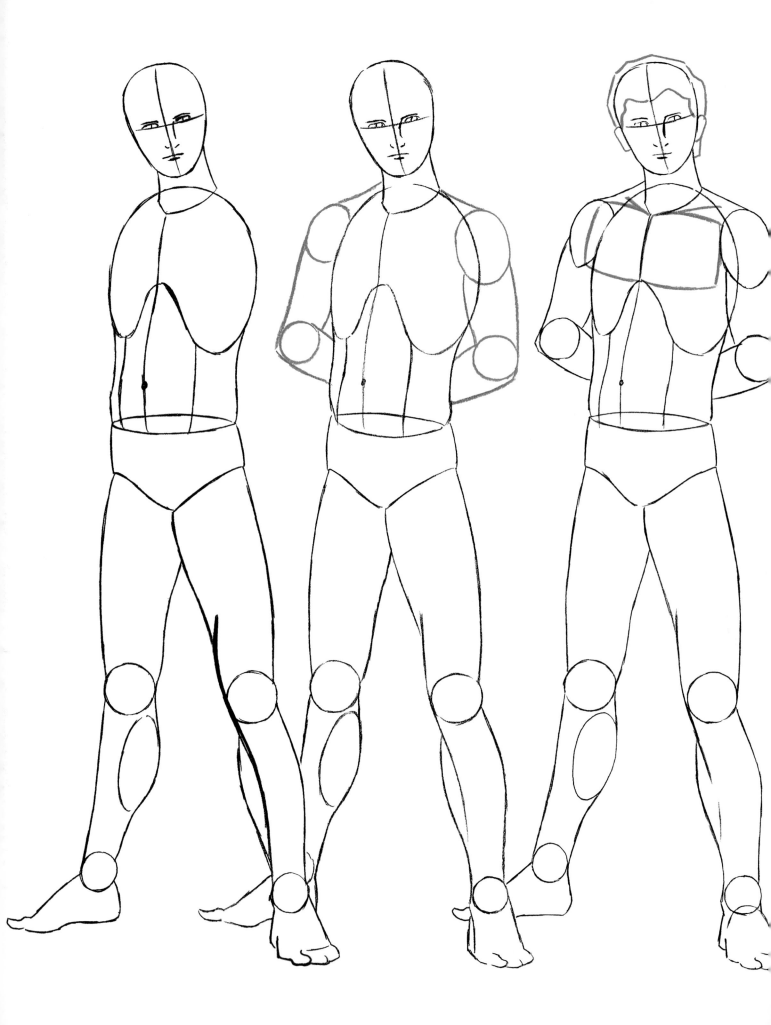

If your goal is...

...to convincingly draw the human head and figure, you've picked up the right book. Perhaps you've seen a few anatomy books that seem confusing and too in-depth for practical figure drawing. Well, this isn't one of those. This is a figure-drawing book, not an anatomy book. It's filled with simple concepts to help you draw the human figure, with only as much focus on anatomy as is absolutely necessary.

This book contains hundreds of illustrations of people in different poses that will serve as your models. You'll learn how to draw them with the correct proportions so that, eventually, you'll be able to come up with your own drawings, from your head, without even copying the ones in this book. And unlike many books on anatomy and figure drawing, this book places an equal emphasis on men and women.

The best part...

...of this book is the abundance of step-by-step instructions. I believe it is virtually impossible, unless you are already an accomplished artist, to copy a drawing of the human figure simply by looking at a finished picture. Therefore, I've used easy-to-follow, progressive steps. New elements in each step are drawn in blue so that you can see exactly which lines have been added to each step. In addition, there are countless hints that call out helpful techniques used by professional artists. These techniques are often subtle, but important, and make all the difference in a drawing.

My goal in drawing and writing this book is to be helpful, inspiring, and, not least of all, to make figure drawing fun. Everything in it is geared toward getting you drawing faster than you thought you'd be able to, and at a higher skill level than you thought you could.

You can do it!

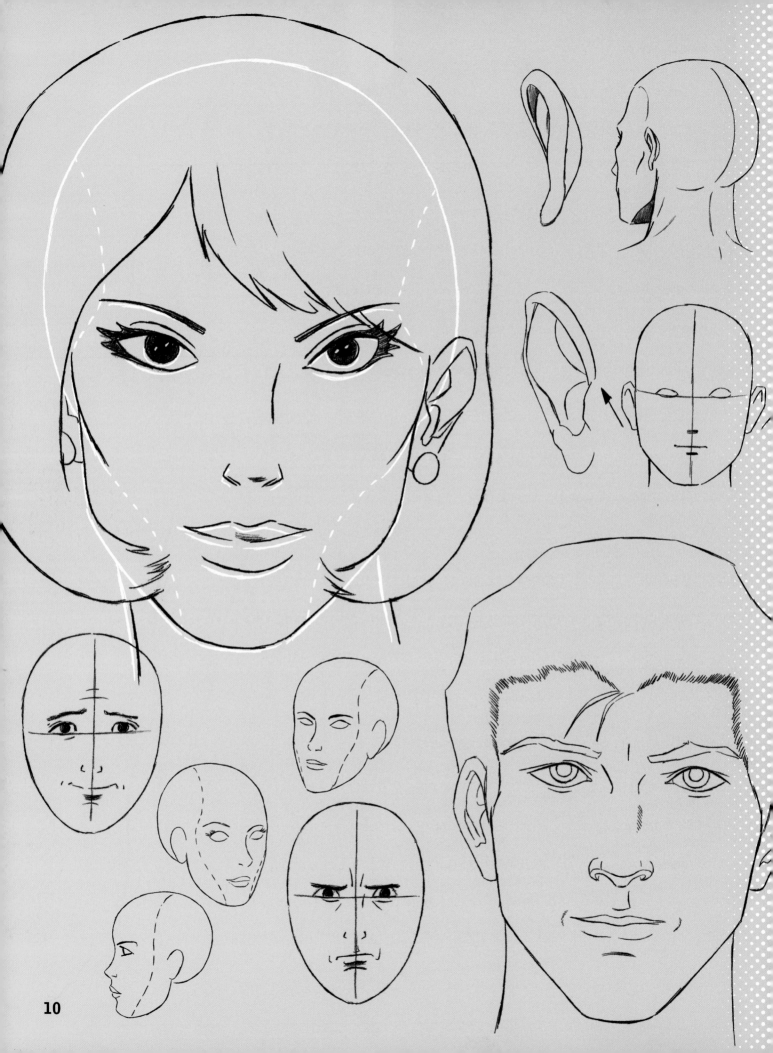

Start at the Top!
Drawing the Head

The head is often the first part of a figure drawing an artist will complete once his or her initial sketch is in place. And it's a good place to begin when learning to draw people. In this chapter, we'll familiarize ourselves with the basic shape of the head, then learn how to draw the eyes and other features and see exactly where to place them for correct proportions. Let's get started!

3/4 Left View

Front View

Profile Left

Be an Egghead: The Basic Head Shape

In order to place the features correctly and end up with a realistic-looking head, we need to start with a good shape. And it has to be one that can be easily reproduced at many angles. A circle is just too cartoony for a realistic drawing of the head, but an egg shape is very close. We'll need to make some minor modifications to this basic shape, but it works as a starting point.

Profile Right

3/4 Right View

Add mass
to back
of head

Make
eye
socket
concave

Indent
jaw line

Basic Egg Shape

Modified Egg Shape

Sculpt the Head

Now that we have the basic outline of the head, we need to sculpt it to make it more closely resemble an actual head. Happily, all that's required are a few minor adjustments.

Head Shape: Male Vs. Female

This "bump" is the cheek muscle

Here's a hint that will help make your characters look more feminine or more masculine. When the male head is posed in a 3/4 view, there are "bumps" on the far side of the face—the cheekbone, the cheek muscle and the chin. We eliminate the cheek muscle in females, for a sleeker, more feminine appearance.

13

Natural Contours of the Face

The head is not flat, nor is it perfectly round. The dotted lines in these drawings show you where the planes of the face change angles. It's sort of a "map" of the head. Let's take a look at these changes of planes at various angles.

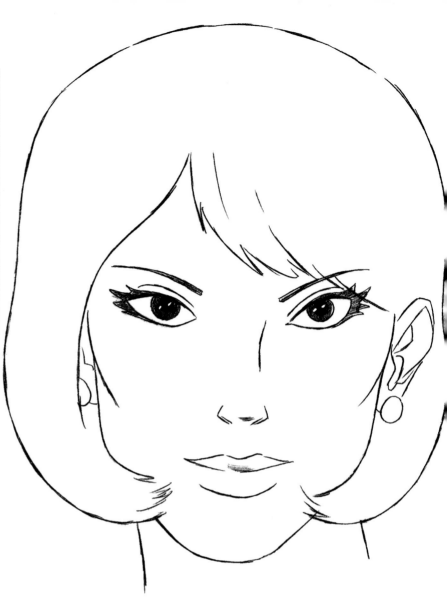

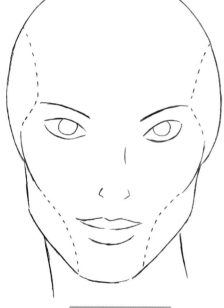

Front View

Notice how the contour lines travel along (are continuations of) the natural path of the cheekbones.

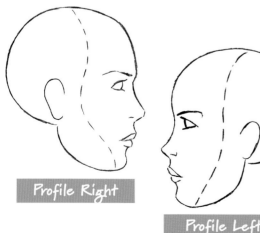

Profile Right

Profile Left

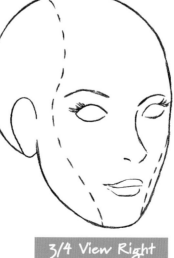

3/4 View Right

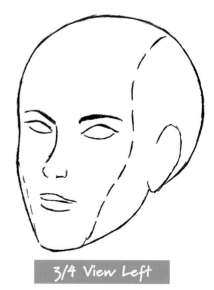

3/4 View Left

Shading the Face

Most light comes from above, in the form of sunlight or overhead lighting. The light hits the protruding parts of the head, causing them to cast shadows below and to the side. These shadows add a sense of depth and a feeling of solidity to the head, making it look like it was carved from a block of stone.

Eye socket

Side of nose

Underside of nose

Shadow of nose

Upper lip

Underside of bottom lip

Underside of chin

The Eyes

The eyes are arguably the most important features of the face when drawing the head, because they appear close to the middle of the head and because they're so expressive. Effectively drawn eyes create a direct link between the viewer and the image on paper.

The shape of the eye in the front view is totally different from the side view. Vary the tone (darkness) of the pupil, iris, eyebrow and eyelids to bring the eyes forward. The lines of the eyelids are usually drawn darker than the other lines of the face.

The upper eyelid casts a subtle but nonetheless visible shadow on the eyeball, which adds a feeling of depth and roundness to the eye.

Female
▶The woman's eye is almond-shaped with thin, arching eyebrows. The eyelashes brush softly to one side.

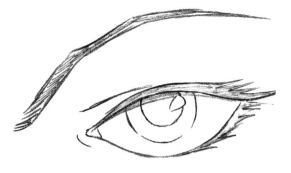

Male
▶The man's eye is also almond-shaped, but he has a heavier upper eyelid and a heavier eyebrow. You can omit the eyelashes.

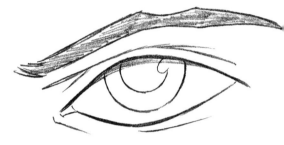

Front View

Female
▶The eyelashes extend significantly forward and backward. The eyebrow arches from high to low.

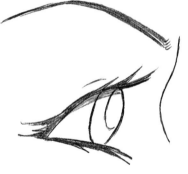

Male
▶The eyelid extends slightly over the eyeball. The eyebrow is flatter and lower.

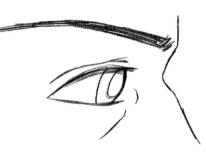

Profile

16

Common Eye Shapes

There are as many types of eyes as there are people who have eyes. However, for drawing purposes, there are three basic shapes for men and three common types for women.

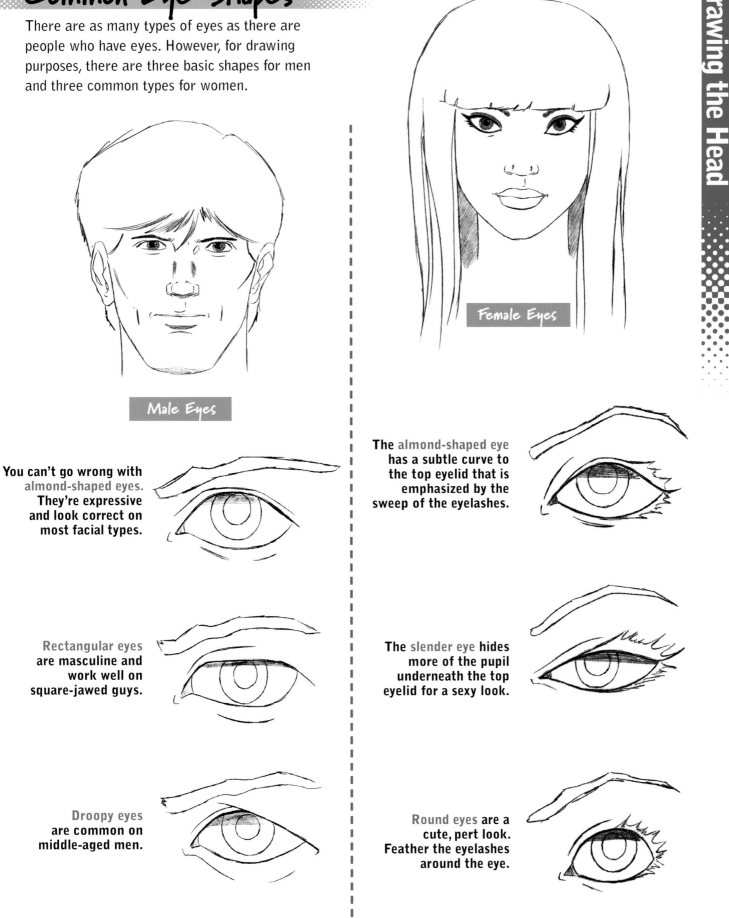

Male Eyes

Female Eyes

You can't go wrong with **almond-shaped eyes**. They're expressive and look correct on most facial types.

The **almond-shaped eye** has a subtle curve to the top eyelid that is emphasized by the sweep of the eyelashes.

Rectangular eyes are masculine and work well on square-jawed guys.

The **slender eye** hides more of the pupil underneath the top eyelid for a sexy look.

Droopy eyes are common on middle-aged men.

Round eyes are a cute, pert look. Feather the eyelashes around the eye.

The Nose and Mouth

I like to think of the nose and mouth as a unit because the nose anchors the mouth in place. Match up the bottom of the nose with the "cupid's bow" of the lips (the depression in the middle of the upper lip) to get the alignment right.

Here are a few practice examples of noses and lips, at various angles. There will be opportunities throughout this book to draw features at different angles as our subjects take on a wide variety of poses. Remember that angles not only include left and right, but up and down as well.

Male Noses

Right

Left

Right, Down

Left, Down

Front

▶ In the "up" angle, the mouth tends to curve down.

Up Angle

Men

When drawing men, you can add more detail to the nose than when drawing women, and they'll still look appealing.

Front View

Profile

▼ In a 3/4 view, the lips are always longer on the near side than the far side.

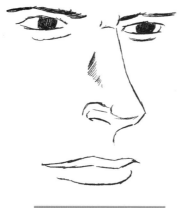
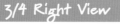

3/4 Right View

▼ The "thumbprint" on the upper lip, just below the nose, is more evident on men than women.

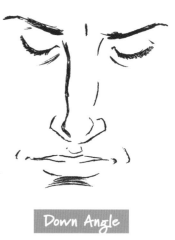

Down Angle

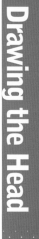

Female Noses

Right

The nose tip angles up in a profile.

Left

Front

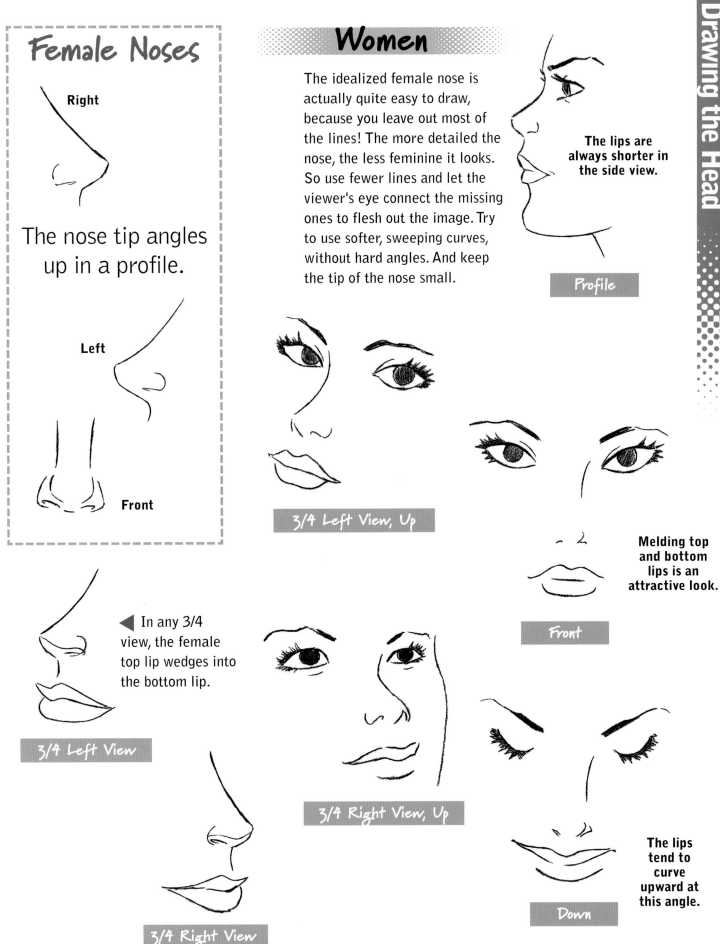

Women

The idealized female nose is actually quite easy to draw, because you leave out most of the lines! The more detailed the nose, the less feminine it looks. So use fewer lines and let the viewer's eye connect the missing ones to flesh out the image. Try to use softer, sweeping curves, without hard angles. And keep the tip of the nose small.

The lips are always shorter in the side view.

Profile

3/4 Left View, Up

Melding top and bottom lips is an attractive look.

Front

◀ In any 3/4 view, the female top lip wedges into the bottom lip.

3/4 Left View

3/4 Right View, Up

The lips tend to curve upward at this angle.

Down

3/4 Right View

19

The Ears

Ears are basically unisex. Male and female ears are interchangeable in shape, although female ears are usually smaller. And a woman's ears are often hidden by her hair, making them even easier to draw!

Front View

The ears don't stick straight out to the sides, flapping like a cartoon. Nor are they pasted to the sides of the head. They're somewhere in between.

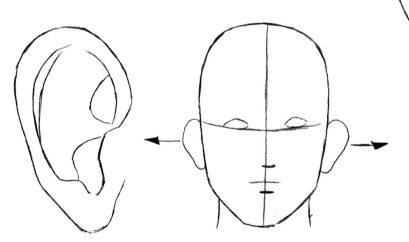

Ears stick straight out, making the character look goofy.

The "wrong" example shown here is actually the correct way to draw the ears in profile!

Right!

Ears angled back and away from the head.

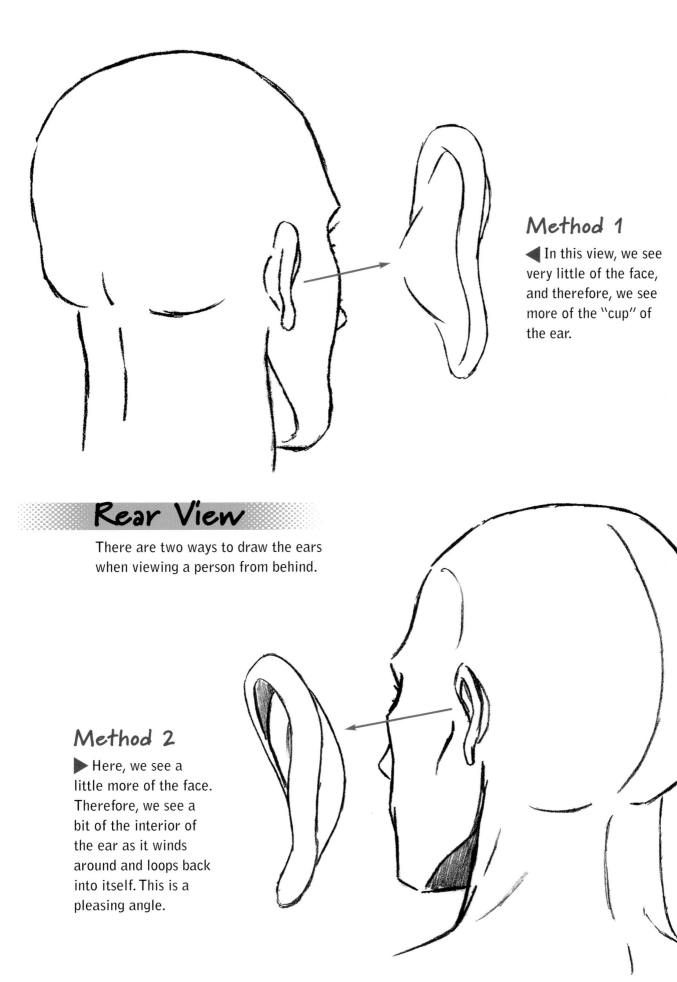

Method 1

◄ In this view, we see very little of the face, and therefore, we see more of the "cup" of the ear.

Rear View

There are two ways to draw the ears when viewing a person from behind.

Method 2

► Here, we see a little more of the face. Therefore, we see a bit of the interior of the ear as it winds around and loops back into itself. This is a pleasing angle.

Jaw Shapes

The jaw is basically a U shape that cups the bottom of the head. You adjust the shape of the jaw to enhance the character type. For example, an athletic guy will be best served with a square jaw, whereas a meek guy will look more convincing with a subtler jaw shape. The female jaw varies less, but can drawn on the fuller side or more slender.

Square
▶ The angles of the chin occur low on the face.

Sculpted
▶ This is a sleeker look, with sharp angles carved out of the head.

Round
▶ This is a pleasing look, without any angular break. Softer lines create this jaw in the shape of a giant U.

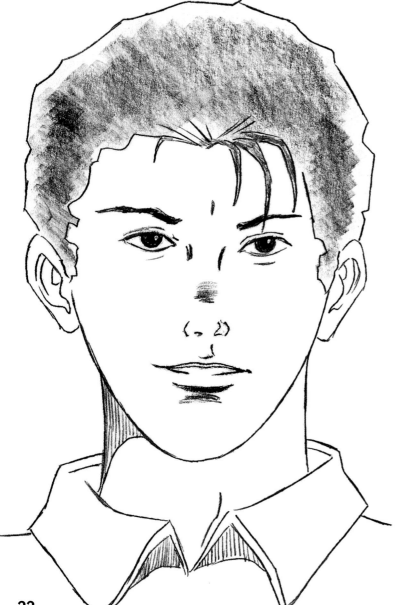

The Chin
(Yep, It's a Muscle)

The chin is actually a muscle. It can move up and down depending on the person's expression. But we're mainly concerned with the fact that it has mass, and, therefore, dimension—it isn't flat.

Visualize the chin as a ball that has been cut in half and pasted on the face. That will make it easier to turn the head at various angles and maintain the semi-spherical chin shape. A woman's chin is not nearly as pronounced as a man's.

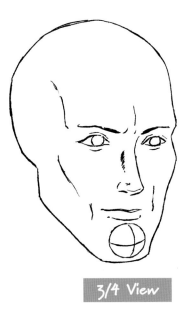

3/4 View

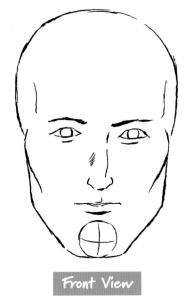

Front View

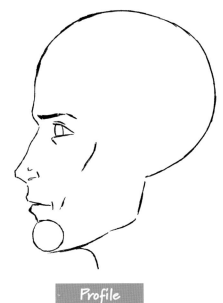

Profile

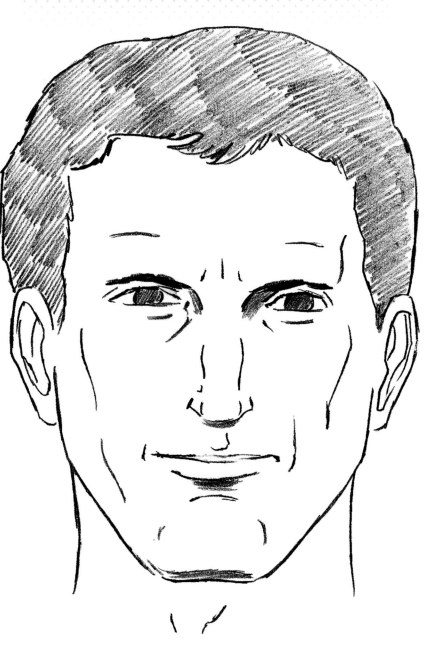

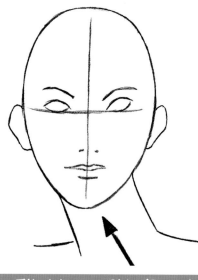

Tilted to One Side (Dynamic)

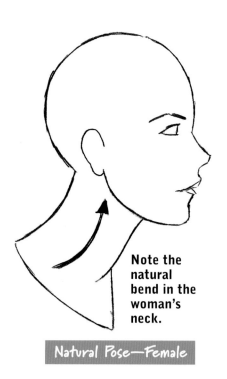

Note the natural bend in the woman's neck.

Natural Pose—Female

Natural Angles of the Neck

Angling the neck infuses a pose with energy. It's also more natural than a straight neck, as people tend to bend and twist their necks. If the neck is straight, the pose tends to look stiff. Changing the angle of the neck adds variety to a pose.

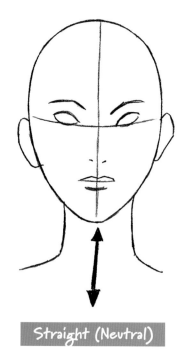

Straight (Neutral)

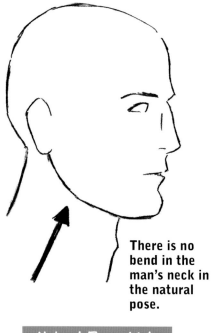

There is no bend in the man's neck in the natural pose.

Natural Pose—Male

Tilted Back

Tilted Down

24

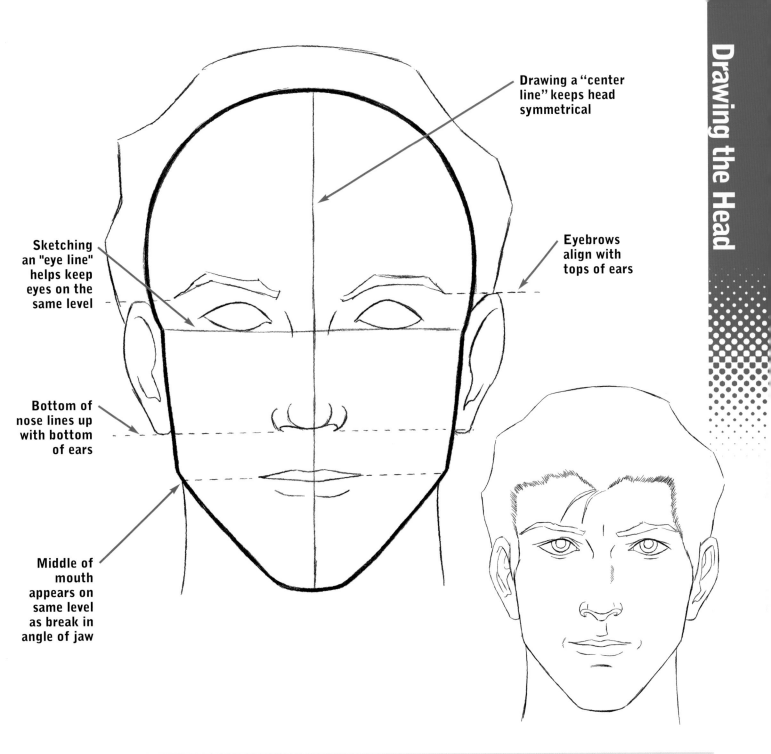

Drawing a "center line" keeps head symmetrical

Eyebrows align with tops of ears

Sketching an "eye line" helps keep eyes on the same level

Bottom of nose lines up with bottom of ears

Middle of mouth appears on same level as break in angle of jaw

Check Your Proportions!

You know how you sometimes work hard to get a drawing just right, and then look over the final product, only to realize that—yikes!—your proportions are out of whack? That big, ugly eraser has to come out—and say bye-bye to your hard-won creation. Kiss those dark days goodbye. You'll now be able to check your proportions at the initial sketch phase to make sure they're right. There are certain guidelines for idealized proportions that, when followed, produce a convincing drawing. I call them "guidelines" rather than "rules" because everything can be reinterpreted according to your personal taste.

The Idealized Face

Here are a few hints for placing the features correctly on the idealized female face. A commonly held concept in art is that the nostrils are the width of the tear ducts. However, on *idealized* female figures, who tend to have small nostrils, the inner eyebrows are the width of the nostrils. Another misconception is that the lips align with the outside of the pupils. Maybe so, on ordinary females but on idealized females, who have thicker, shorter lips, the inner eyeball is a better marker of the width.

Bunching the eyes and other features together toward the lower half of the face results in a youthful look— for our youth-obsessed society!

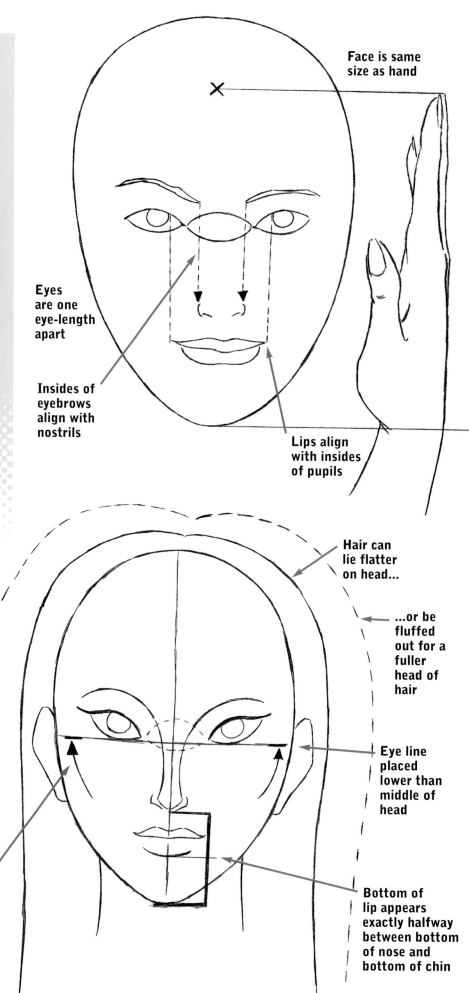

Face is same size as hand

Eyes are one eye-length apart

Insides of eyebrows align with nostrils

Lips align with insides of pupils

Hair can lie flatter on head...

...or be fluffed out for a fuller head of hair

Eye line placed lower than middle of head

Bottom of lip appears exactly halfway between bottom of nose and bottom of chin

Cheekbone begins just below eye level on men and women

26

Pleased

Corners of mouth turn up, pupils get bigger, and eyebrows arch.

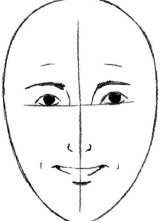

Scared

Eyes show lots of "white" and mouth compresses.

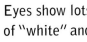

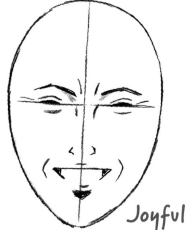

Joyful

Squinty eyes and a broad smile.

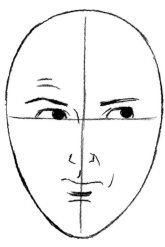

Worried

Forehead wrinkles, eyebrows turn up and mouth turns down.

Expressions

Now we're going to take the egg shape with which we've become so familiar and twist and tug its simple features in a few different directions. This will result in a series of classic expressions and attitudes.

Skeptical

Sideways glance with pursed lips and one high arching eyebrow.

Angry

Eyebrows crush down on eyes, and lips press together in a hard line.

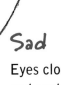

Sad

Eyes close and eyebrows turn up. Mouth turns down slightly.

Sympathetic

Upturned eyebrows and a small smile.

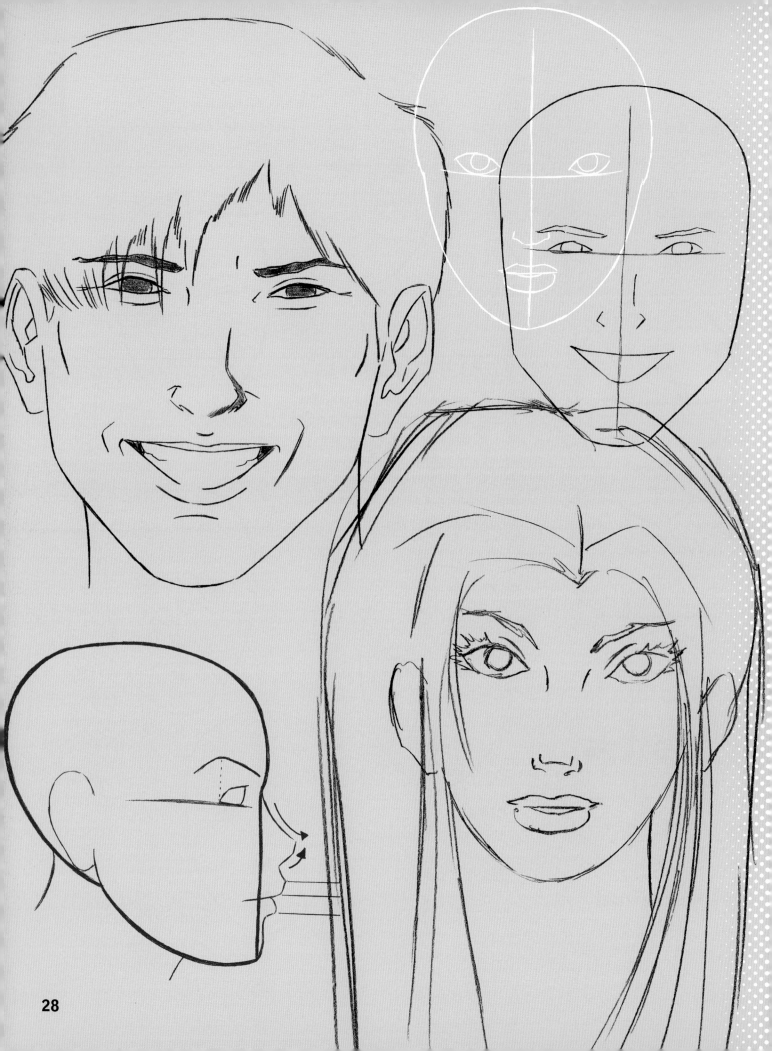

Break It Down!

Step-by-Step Heads

N ow that we've covered the basics, we'll put it all together by drawing a variety of heads from start to finish. We'll take them gradually, so you'll be able to grasp the progression as we go along. And don't feel that your drawings have to look like carbon copies of mine. Our differences are what make our styles unique. It's the general proportions and principles that should guide you.

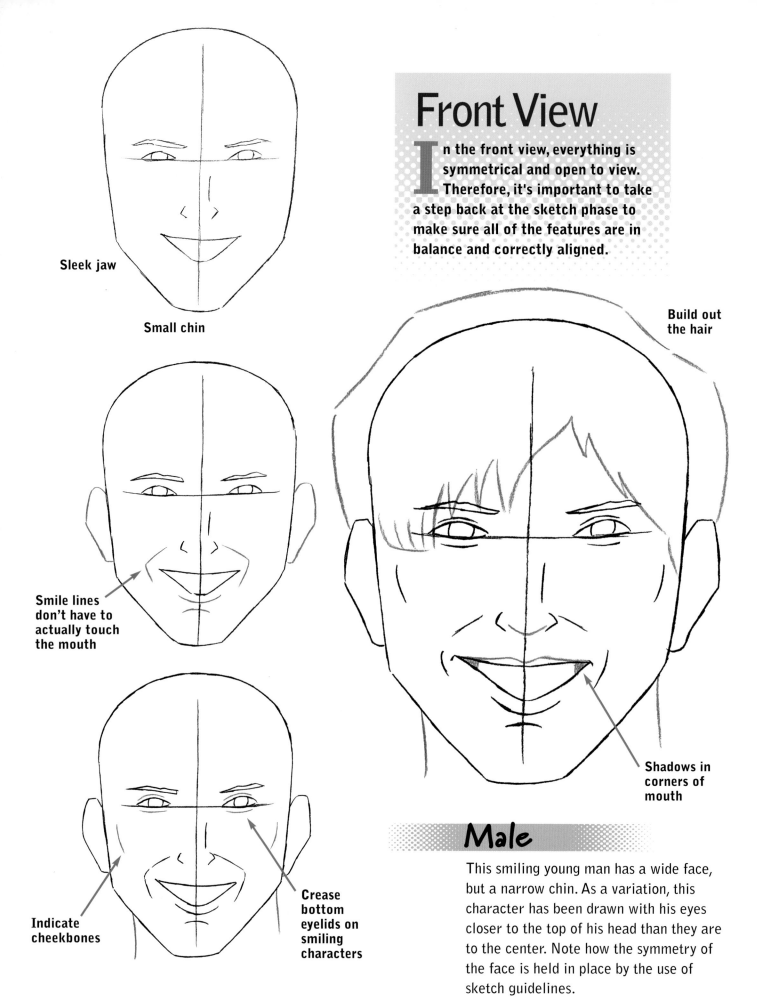

Sleek jaw

Small chin

Front View

In the front view, everything is symmetrical and open to view. Therefore, it's important to take a step back at the sketch phase to make sure all of the features are in balance and correctly aligned.

Smile lines don't have to actually touch the mouth

Build out the hair

Indicate cheekbones

Crease bottom eyelids on smiling characters

Shadows in corners of mouth

Male

This smiling young man has a wide face, but a narrow chin. As a variation, this character has been drawn with his eyes closer to the top of his head than they are to the center. Note how the symmetry of the face is held in place by the use of sketch guidelines.

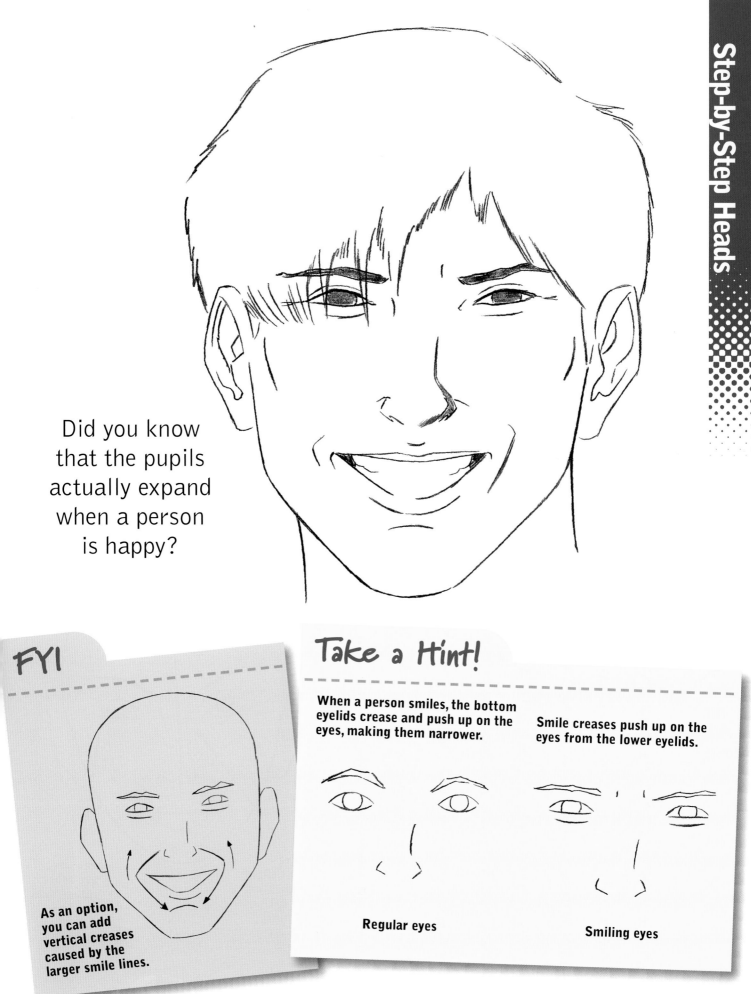

Did you know that the pupils actually expand when a person is happy?

FYI

As an option, you can add vertical creases caused by the larger smile lines.

Take a Hint!

When a person smiles, the bottom eyelids crease and push up on the eyes, making them narrower.

Smile creases push up on the eyes from the lower eyelids.

Regular eyes

Smiling eyes

Female

This pretty female has a minimum of lines on her youthful face, making her simple to draw. But one word of caution: All this simplicity puts more emphasis on the symmetry of her features, because that's all the eye has to look at. So make sure the eyes and eyebrows line up evenly. And be sure the lips align with the middle of the nose, that the ears are on the same level, and so forth.

Take a Hint!

Guidelines help artists make sure that all the features line up correctly.

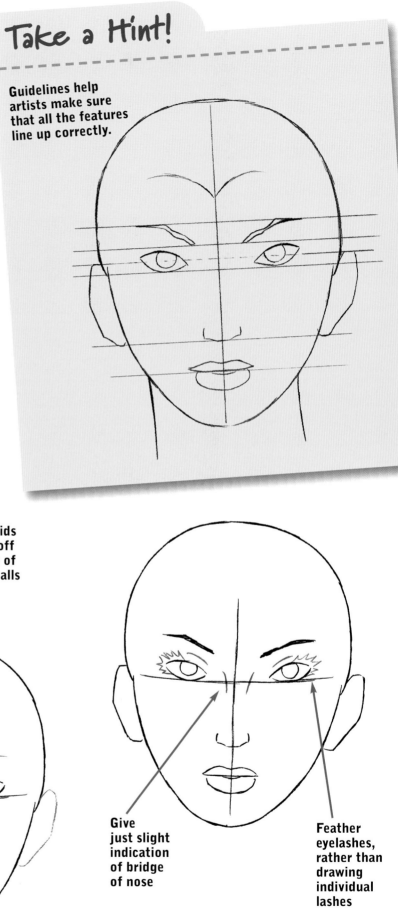

Top half of head slightly larger than lower half

Thick bottom lip hangs down

Eyelids cut off tops of eyeballs

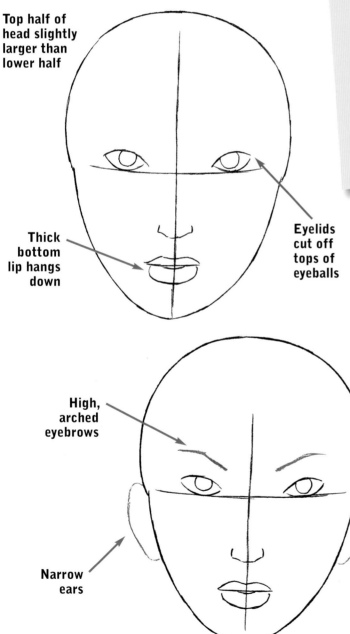

High, arched eyebrows

Narrow ears

Give just slight indication of bridge of nose

Feather eyelashes, rather than drawing individual lashes

Rough Pencil Sketch

Notice how loosely I drew my original sketch. You should strive for long, loose lines, not tight, choppy, constricted lines. One reason why people tighten up is that they are afraid of making mistakes. But professional artists "overdraw" all the time. Their drawings are filled with superfluous lines searching for form. Don't be afraid to make mistakes. Be bold.

Strands of hair fall in front of ears

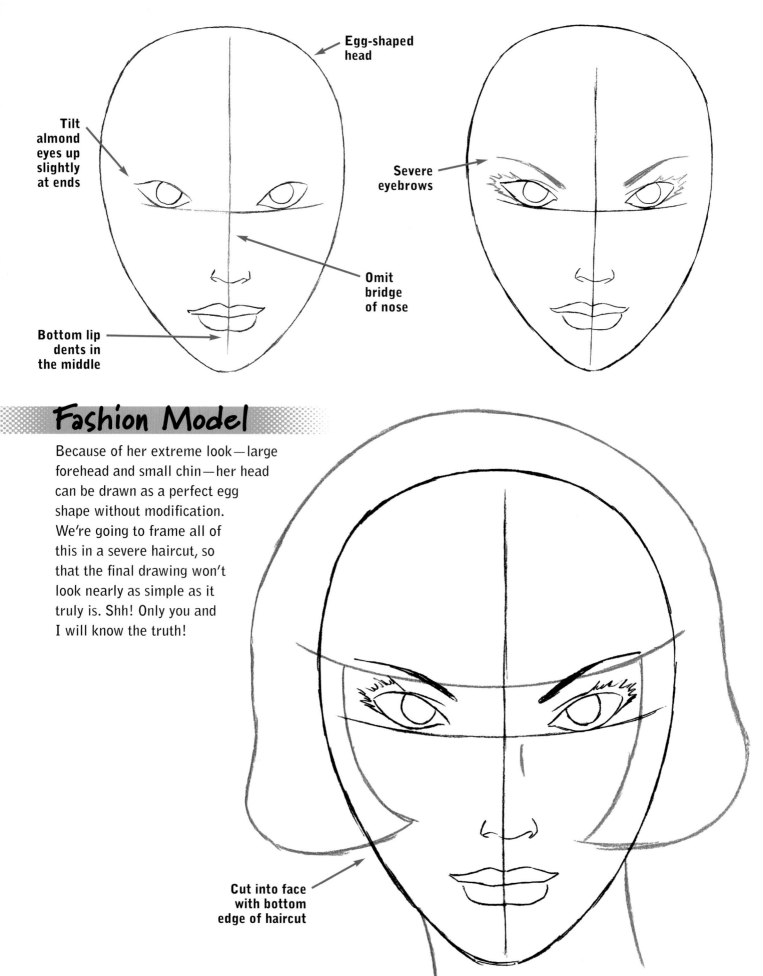

Egg-shaped head

Tilt almond eyes up slightly at ends

Severe eyebrows

Omit bridge of nose

Bottom lip dents in the middle

Fashion Model

Because of her extreme look—large forehead and small chin—her head can be drawn as a perfect egg shape without modification. We're going to frame all of this in a severe haircut, so that the final drawing won't look nearly as simple as it truly is. Shh! Only you and I will know the truth!

Cut into face with bottom edge of haircut

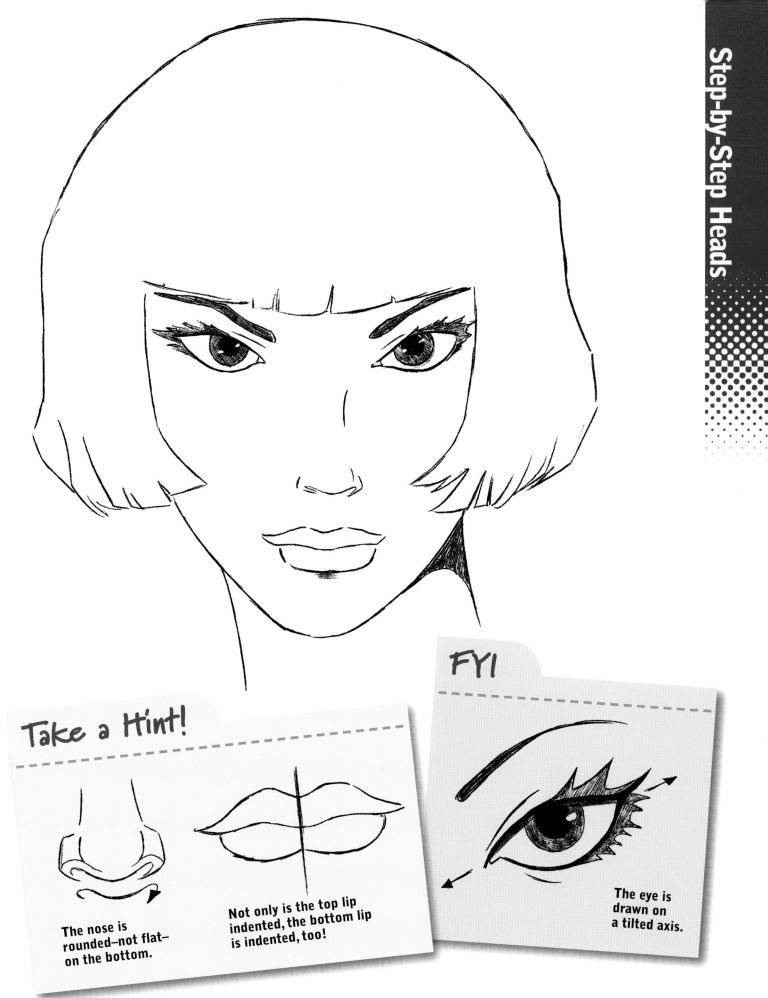

Take a Hint!

The nose is rounded—not flat—on the bottom.

Not only is the top lip indented, the bottom lip is indented, too!

FYI

The eye is drawn on a tilted axis.

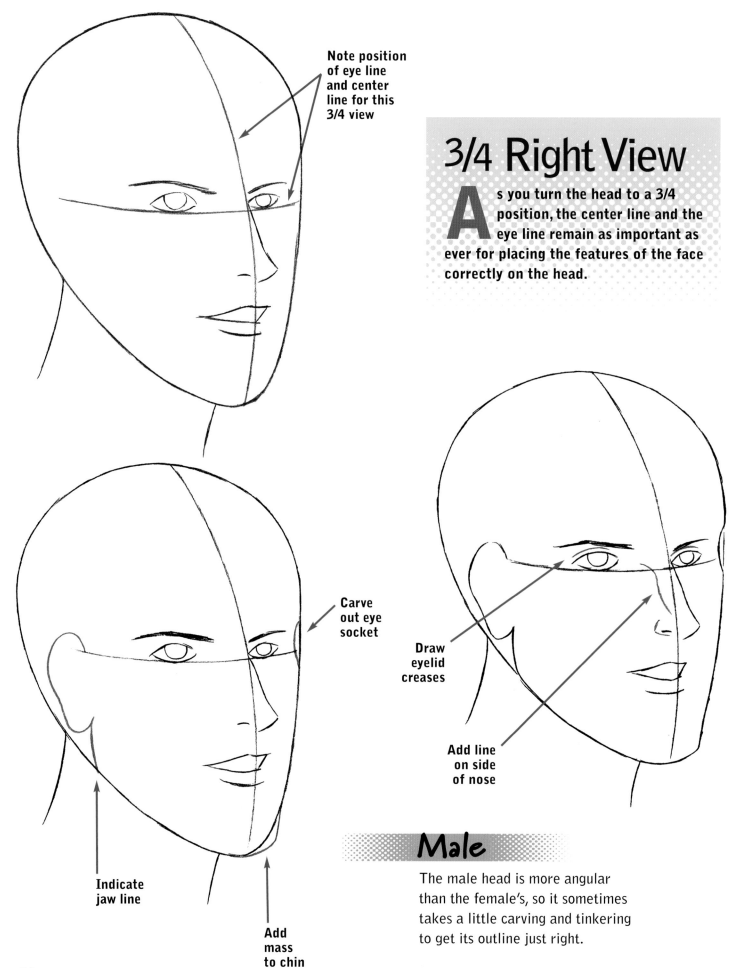

Note position of eye line and center line for this 3/4 view

3/4 Right View

As you turn the head to a 3/4 position, the center line and the eye line remain as important as ever for placing the features of the face correctly on the head.

Carve out eye socket

Draw eyelid creases

Add line on side of nose

Indicate jaw line

Add mass to chin

Male

The male head is more angular than the female's, so it sometimes takes a little carving and tinkering to get its outline just right.

**Add a
full head
of hair**

**Short line under
lower lip shows
roundness of chin**

Shading

I've added a small—a very
small—amount of shading to this
head shot: under the hair, the far
eye, the nose, under the bottom
lip, and under the chin. Shading
is often used, as I've done here,
to indicate the parts of the face
that protrude, which gives the
drawing depth. Shading doesn't
have to be extensive in order to
be effective.

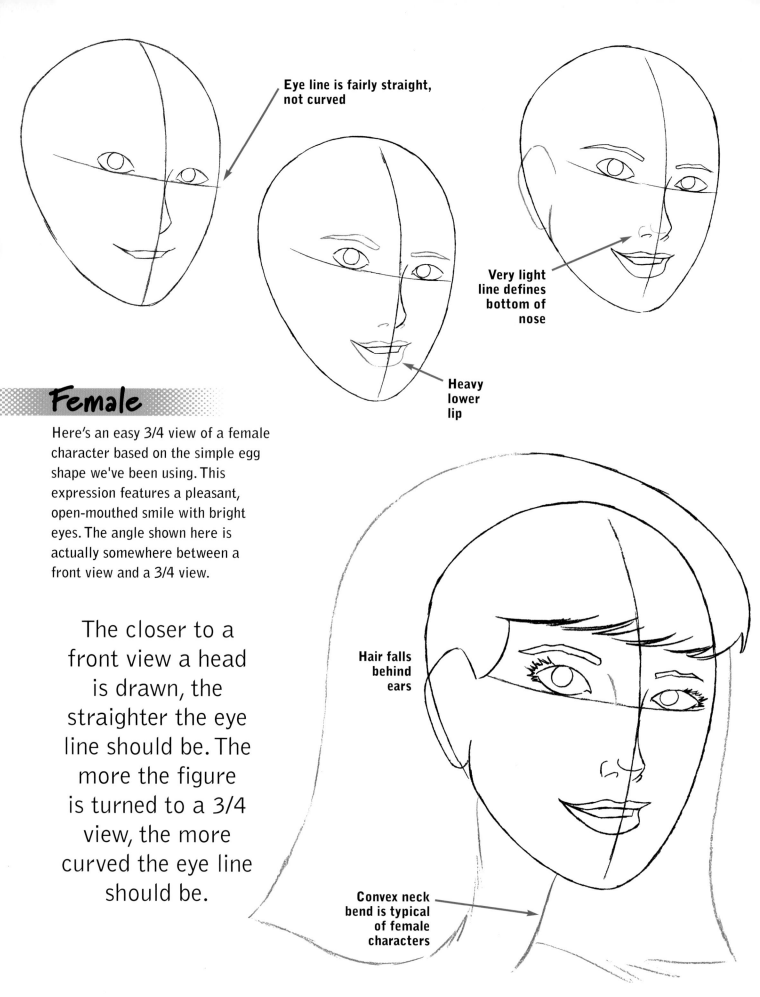

Eye line is fairly straight, not curved

Very light line defines bottom of nose

Heavy lower lip

Female

Here's an easy 3/4 view of a female character based on the simple egg shape we've been using. This expression features a pleasant, open-mouthed smile with bright eyes. The angle shown here is actually somewhere between a front view and a 3/4 view.

The closer to a front view a head is drawn, the straighter the eye line should be. The more the figure is turned to a 3/4 view, the more curved the eye line should be.

Hair falls behind ears

Convex neck bend is typical of female characters

38

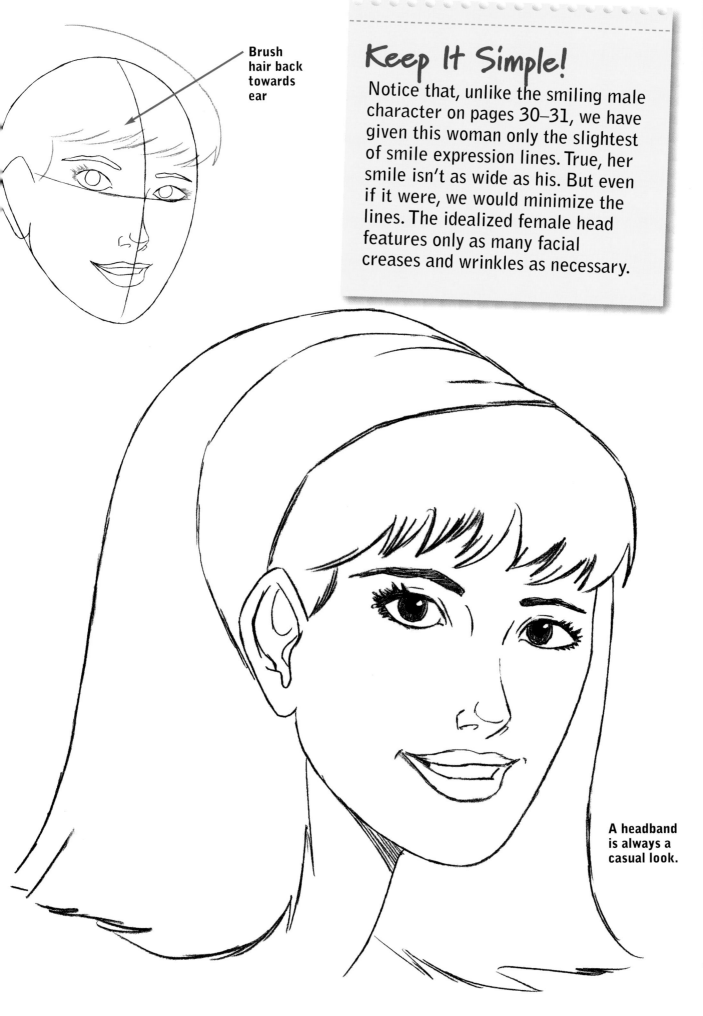

Brush hair back towards ear

Keep It Simple!

Notice that, unlike the smiling male character on pages 30–31, we have given this woman only the slightest of smile expression lines. True, her smile isn't as wide as his. But even if it were, we would minimize the lines. The idealized female head features only as many facial creases and wrinkles as necessary.

A headband is always a casual look.

Even the more advanced drawings of heads all begin at the same place—the basic egg shape!

Male

Here's a highly sculpted look created with sharp angles for the forehead, cheekbone and jaw. There are two tricky things about this drawing: First, the nose is on the long side, which increases your chances of getting a little lost along the way and ending up with a nose that's wandering. Second, this guy has a full upper lip, and in the 3/4 view, that's not the easiest item to draw, especially for a male character. You don't want it to be too full, which could make him look feminine.

Forehead protrudes

Sharp cheekbone

Build out chin

3/4 Left View

The 3/4 view is an ideal angle at which to show off the sculpted look of a model with an angular bone structure. Note the modeling on the far side of the male face.

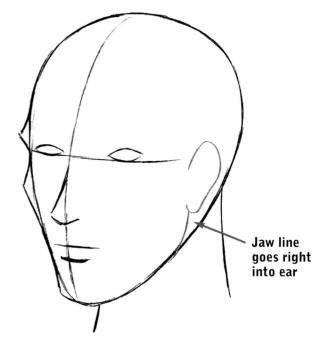

Jaw line goes right into ear

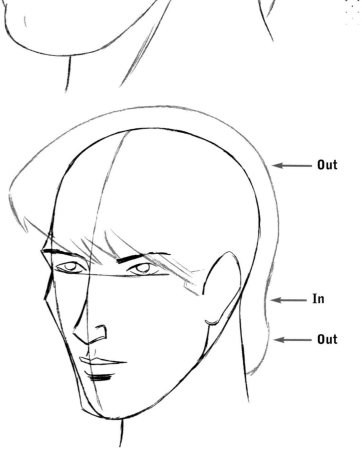

Heads Up!

The hair really does hide a great deal of the head. But we draw the initial structure anyway; otherwise the head shape may start to look weird where the hair begins. The reason the hairstyle looks good is because there's a solid structure underneath, and viewers can sense it, even if they can't see it.

Out

In

Out

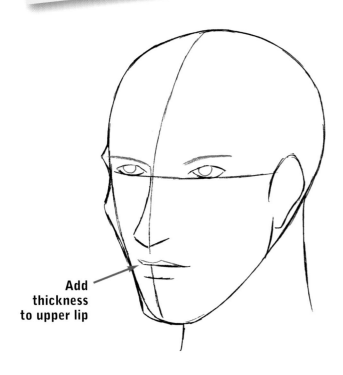

Add thickness to upper lip

41

Female

To contrast the difference between drawing male and female heads, the more angular male 3/4 view we just completed took several modifications to the basic head shape. However, this 3/4 view of a female head starts as an egg shape and remains an egg shape throughout all of the steps.

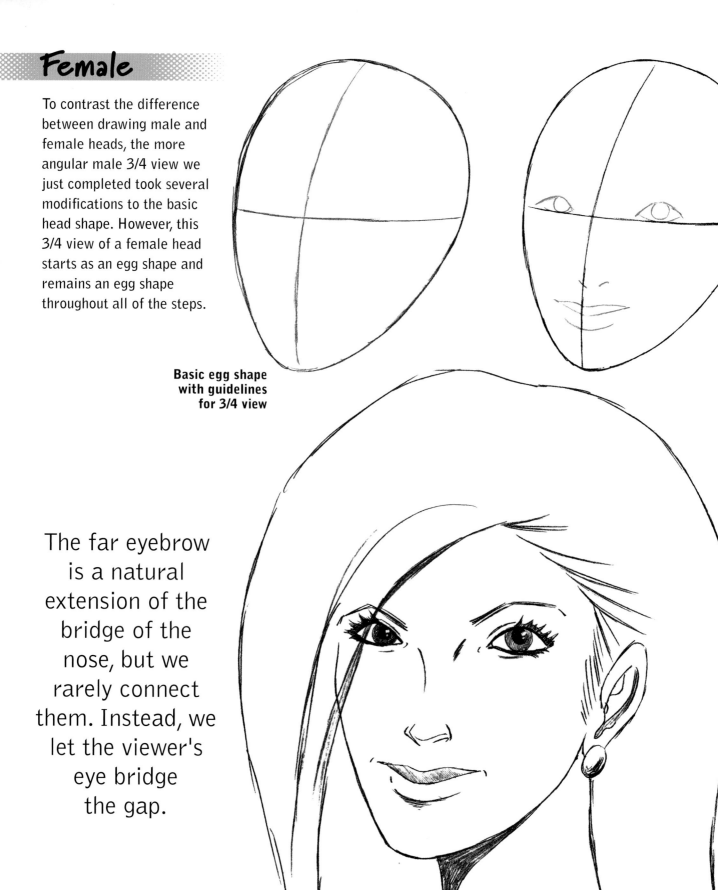

**Basic egg shape
with guidelines
for 3/4 view**

The far eyebrow is a natural extension of the bridge of the nose, but we rarely connect them. Instead, we let the viewer's eye bridge the gap.

Drape the hair partially over one eye for a dramatic look

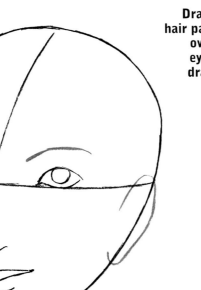

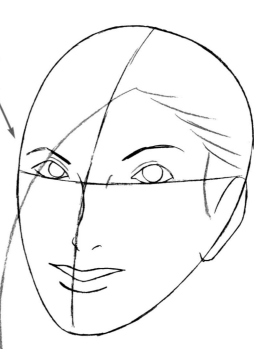

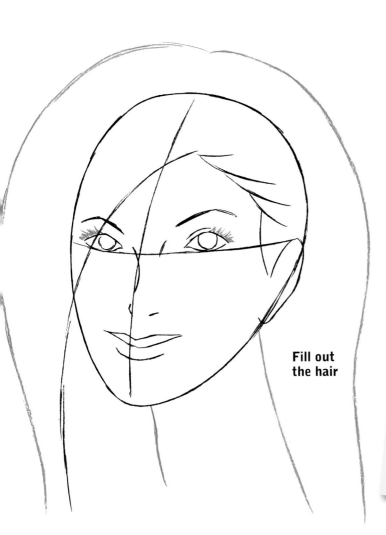

Fill out the hair

Eye See Through You!

It is perfectly fine to eliminate the parts of the eye and eyebrow that are hidden underneath the hair. However, the "see-through hair" convention is a popular look. If your model has pretty eyes, you may not want to leave out her best feature. And since we think of light hair as sort of translucent anyway, we buy the idea that we can see through it. One word of caution: If the character has heavy bangs, this technique may not work so well.

Profile

Of all the angles of the head, the profile is probably the one that differs most between men and women. Women have a small brow, an upturned nose, full lips and a small or even receding chin; men have none of the above. A man's profile is hard looking; a woman's is softer. Let's compare the two visually.

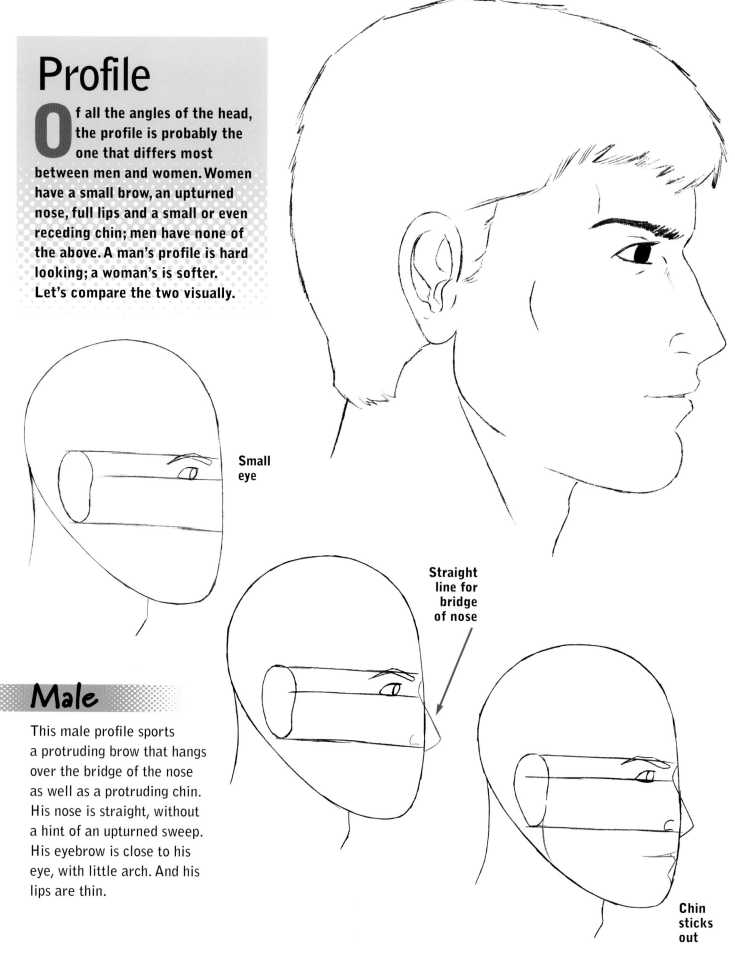

Small eye

Straight line for bridge of nose

Male

This male profile sports a protruding brow that hangs over the bridge of the nose as well as a protruding chin. His nose is straight, without a hint of an upturned sweep. His eyebrow is close to his eye, with little arch. And his lips are thin.

Chin sticks out

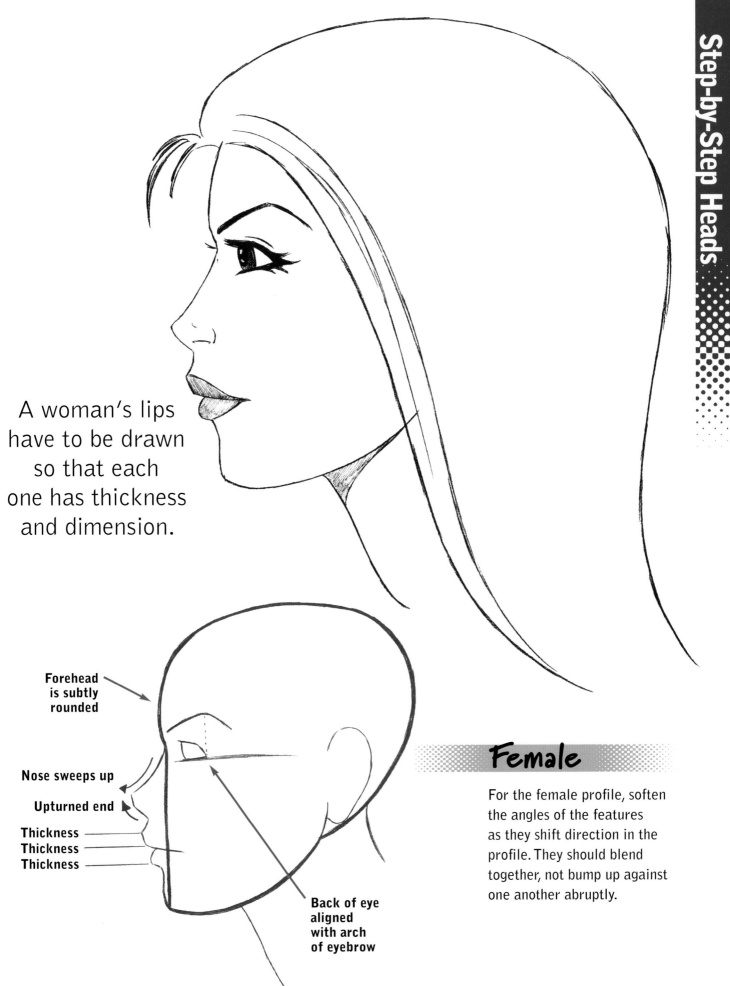

A woman's lips have to be drawn so that each one has thickness and dimension.

Forehead is subtly rounded

Nose sweeps up

Upturned end

Thickness
Thickness
Thickness

Back of eye aligned with arch of eyebrow

Female

For the female profile, soften the angles of the features as they shift direction in the profile. They should blend together, not bump up against one another abruptly.

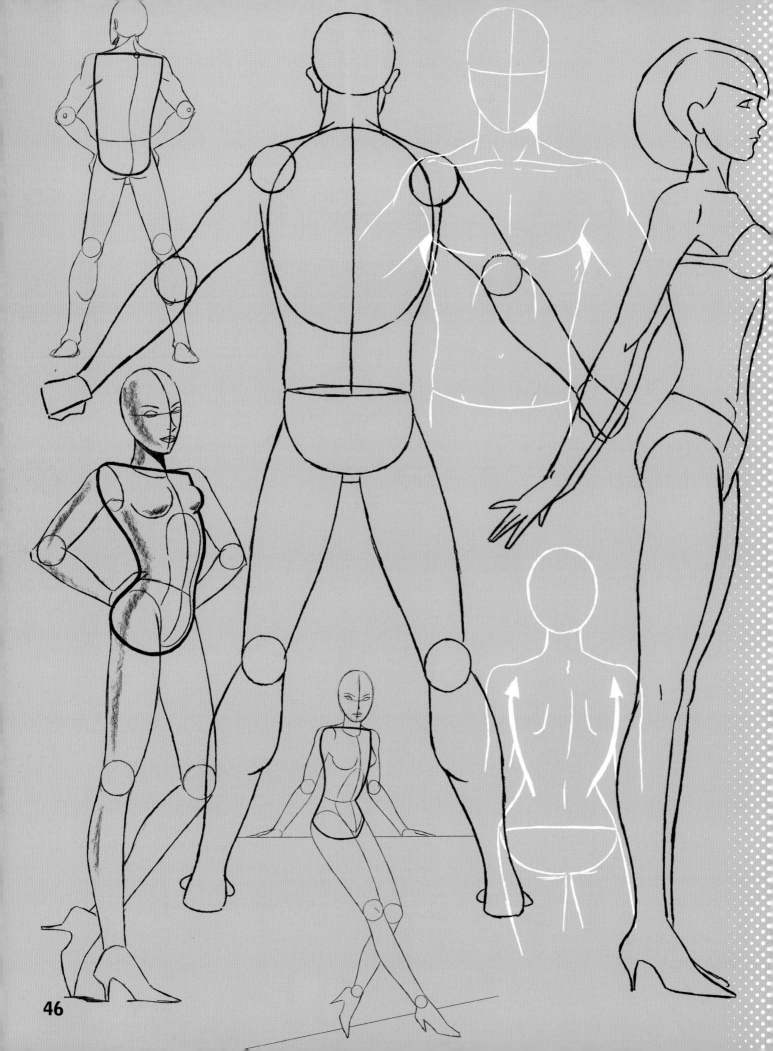

Get Back to Basics!

Drawing the Body

N ow that we've tackled drawing the head, we're going to make the big move you've been waiting for: drawing the entire figure. We'll take it step by step, turning the figure and moving from front pose to side pose to rear pose, for both men and women. And we'll look at a variety of poses simplified to their basic constructions so you can learn how to set up a solid foundation for your figures. Pencils ready?

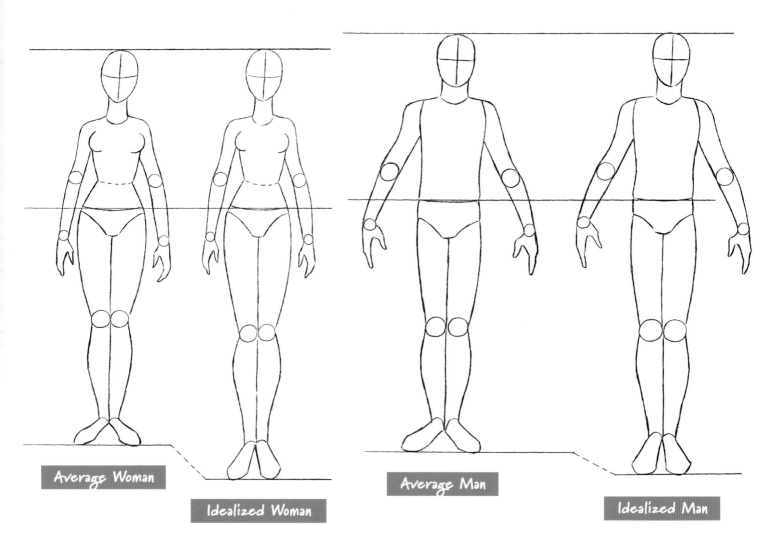

Average Woman

Idealized Woman

Average Man

Idealized Man

Average Vs. Idealized Figures

When drawing idealized figures, we generally add some length to them—but not necessarily to every part of the body. Instead, we mainly lengthen the legs.

If you look at these figures, you'll see that the average and idealized versions of each pair have the same size torsos. They differ only from the legs down to the toes in that the idealized version is longer. The same goes for the female versions. This extra length prevents the female figure from looking frumpy. In men, the added length gives more heroic appeal.

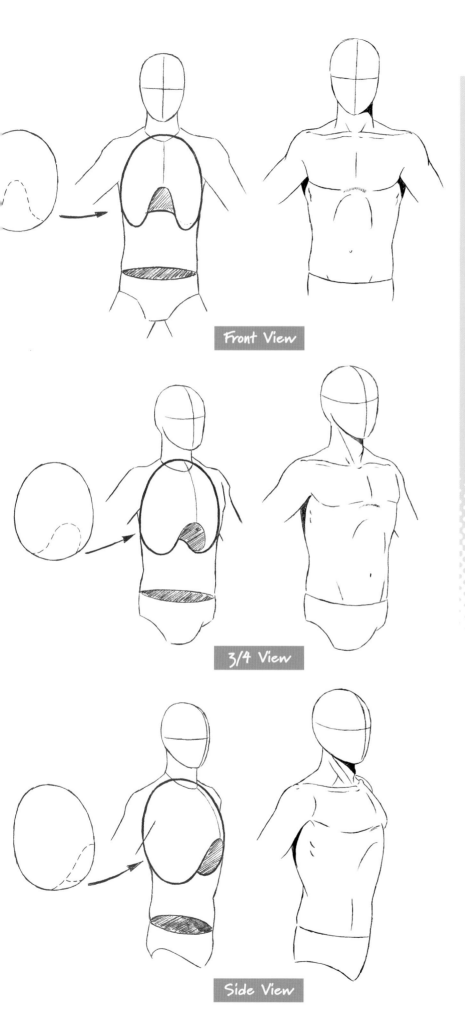

Front View

3/4 View

Side View

Drawing the Rib Cage

The torso is the foundation of the body, and the rib cage is the foundation for drawing the torso. At its most basic, the rib cage can be drawn as just a hollow oval. This is a similar technique to using the egg shape as the foundation for drawing the head. And just like the head, we have to be able to turn the rib cage at different angles as the body turns. In these examples, I've sculpted the bottom of the rib cage and indicated its interior, but you don't have to. A simple oval is all that's required.

The side view on this page is actually not a true side view, because a bit of the far side of the body peeks out. This makes the drawing more dynamic.

Front View

Now we're going to take basic constructions of male and female figures and turn them around to different views so that you can get a clear understanding of how to draw the figure at all angles.

To best show the body proportions, I've selected simple, symmetrical, stable poses with the feet wide apart and firmly planted on the ground.

Male

When drawn in a front view, the idealized male figure should appear sturdy, balanced and athletic.

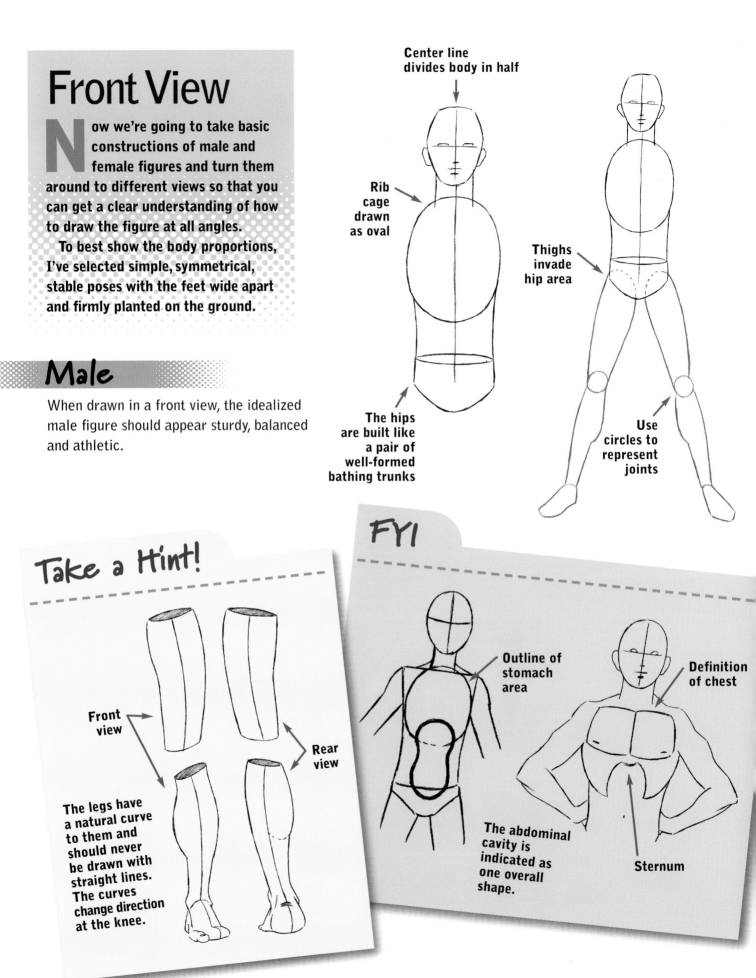

Center line divides body in half

Rib cage drawn as oval

Thighs invade hip area

The hips are built like a pair of well-formed bathing trunks

Use circles to represent joints

Take a Hint!

Front view

Rear view

The legs have a natural curve to them and should never be drawn with straight lines. The curves change direction at the knee.

FYI

Outline of stomach area

Definition of chest

The abdominal cavity is indicated as one overall shape.

Sternum

50

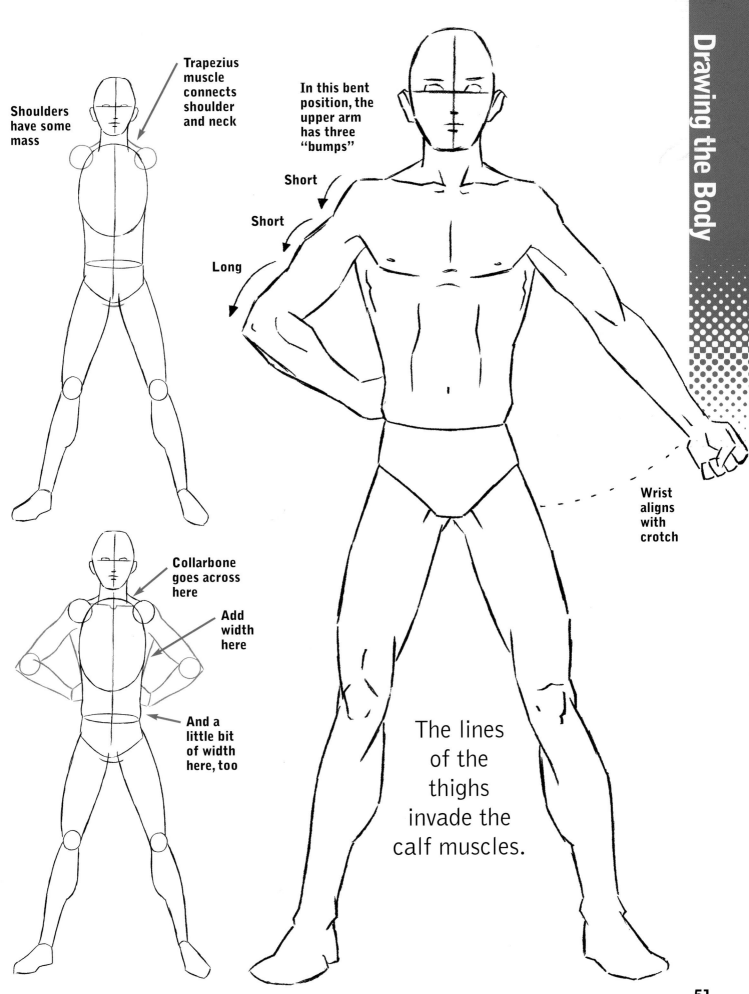

Shoulders have some mass

Trapezius muscle connects shoulder and neck

In this bent position, the upper arm has three "bumps"

Short

Short

Long

Collarbone goes across here

Add width here

And a little bit of width here, too

Wrist aligns with crotch

The lines of the thighs invade the calf muscles.

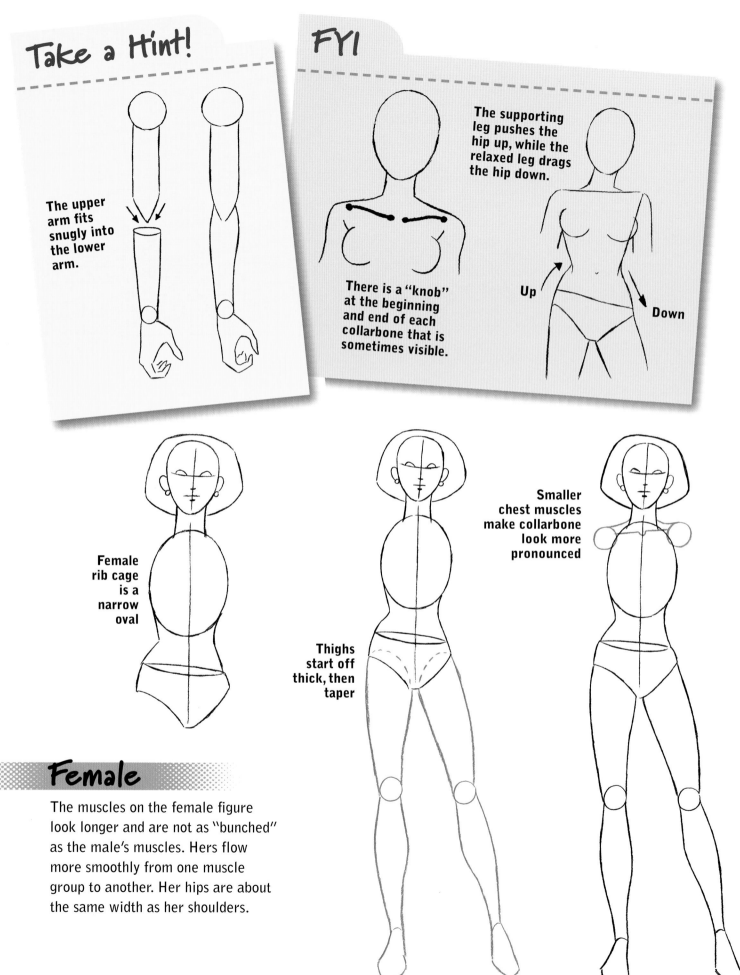

Take a Hint!

The upper arm fits snugly into the lower arm.

FYI

The supporting leg pushes the hip up, while the relaxed leg drags the hip down.

There is a "knob" at the beginning and end of each collarbone that is sometimes visible.

Up

Down

Female rib cage is a narrow oval

Thighs start off thick, then taper

Smaller chest muscles make collarbone look more pronounced

Female

The muscles on the female figure look longer and are not as "bunched" as the male's muscles. Hers flow more smoothly from one muscle group to another. Her hips are about the same width as her shoulders.

Many artists, and virtually all fashion artists, draw their female models in high heels, as it adds yet more length to the character and causes the leg muscles to flex for better definition and shapeliness.

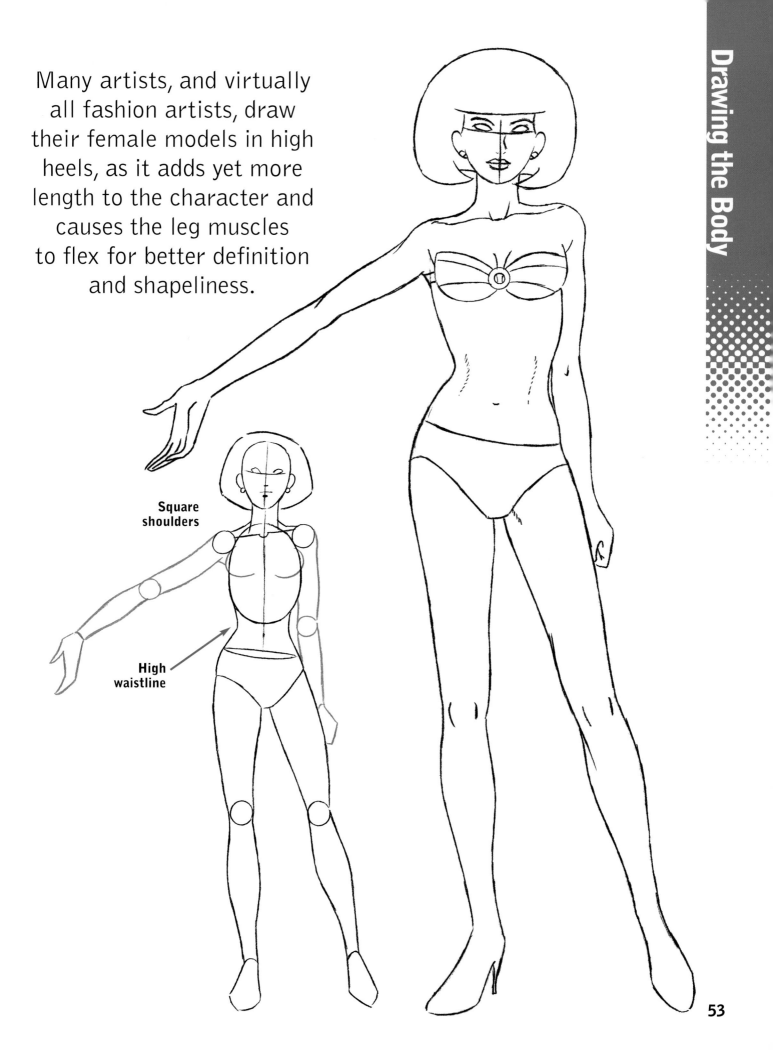

Square shoulders

High waistline

Side View

The side view lacks the symmetry we've enjoyed in front poses, so this is probably a more difficult stance at first glance. But once you know what to look for, it becomes relatively easy! For example, there is a lot of mass to the back in a side pose. And the curve of the small of the back should be pronounced — no stiff backs for us! The front of the body requires some definition for the three different muscle groups: the chest and the upper and the lower stomach muscles. These secrets, once incorporated, make the side view a much easier pose to draw than most others.

Male

Beginners tend to draw men in the side view in very stiff poses. To loosen them up, push the head forward slightly and put a significant bend in the small of the back.

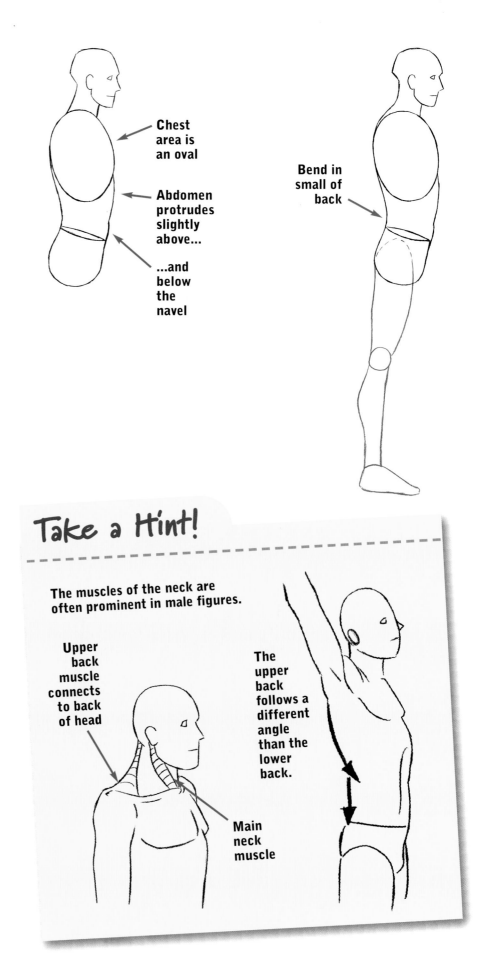

Chest area is an oval

Abdomen protrudes slightly above...

...and below the navel

Bend in small of back

Take a Hint!

The muscles of the neck are often prominent in male figures.

Upper back muscle connects to back of head

Main neck muscle

The upper back follows a different angle than the lower back.

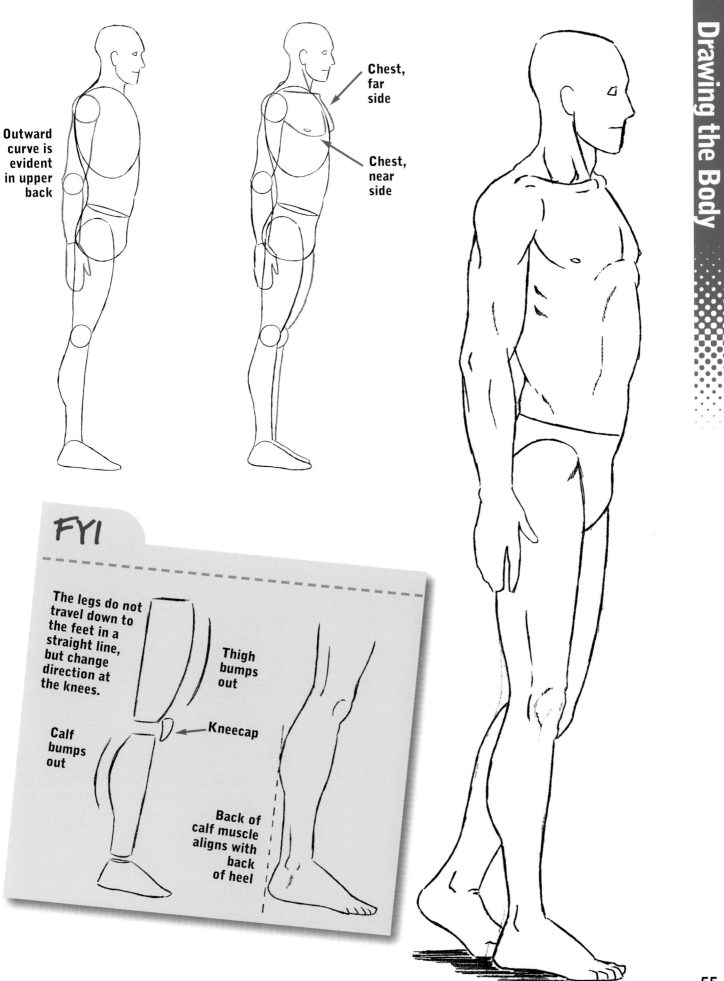

Outward curve is evident in upper back

Chest, far side

Chest, near side

FYI

The legs do not travel down to the feet in a straight line, but change direction at the knees.

Thigh bumps out

Calf bumps out

Kneecap

Back of calf muscle aligns with back of heel

Female

To create long, flowing lines that connect one part of the body to the next, try not to get caught up in the bumps of individual muscles along the way. Concentrate on depicting the grace and beauty of the female form, with the body going in more at the waistline, and the legs tapering more at the knees and ankles as well.

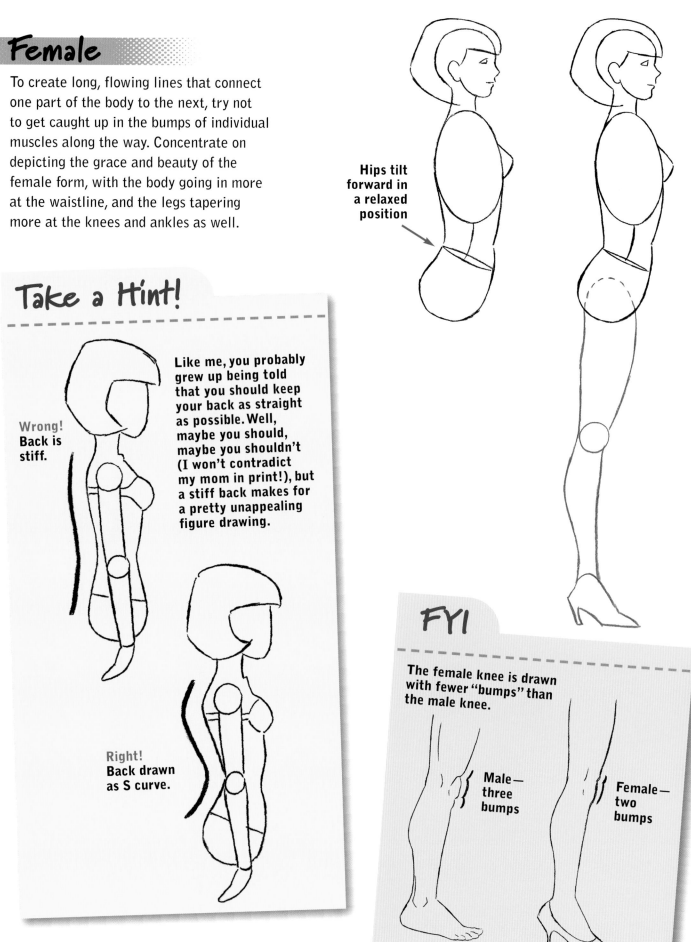

Hips tilt forward in a relaxed position

Take a Hint!

Wrong! Back is stiff.

Like me, you probably grew up being told that you should keep your back as straight as possible. Well, maybe you should, maybe you shouldn't (I won't contradict my mom in print!), but a stiff back makes for a pretty unappealing figure drawing.

Right! Back drawn as S curve.

FYI

The female knee is drawn with fewer "bumps" than the male knee.

Male— three bumps

Female— two bumps

Always draw in far arm and leg

Tummy definition line

Hip bone can be seen just above thigh

Moving the arms back like this is somewhat unnatural, but it makes the silhouette of the body easier to see. These initial poses are just to demonstrate the building blocks of the figures. More natural poses are coming soon!

From the rear view, the front of the foot peeks out from either side of the heel.

Left foot Right foot

The outer ankle bone is lower than the inner ankle bone.

Upper back muscles travel to base of skull...

...then fork off and continue to wind around shoulder blades.

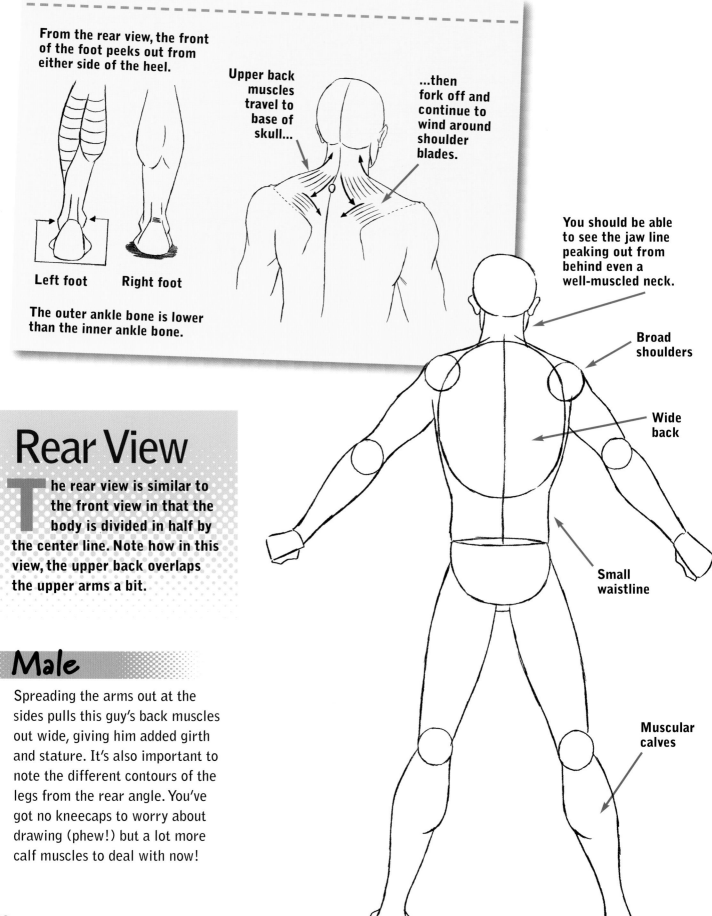

You should be able to see the jaw line peaking out from behind even a well-muscled neck.

Broad shoulders

Wide back

Small waistline

Muscular calves

Rear View

The rear view is similar to the front view in that the body is divided in half by the center line. Note how in this view, the upper back overlaps the upper arms a bit.

Male

Spreading the arms out at the sides pulls this guy's back muscles out wide, giving him added girth and stature. It's also important to note the different contours of the legs from the rear angle. You've got no kneecaps to worry about drawing (phew!) but a lot more calf muscles to deal with now!

FYI

Here are some important points in the topography of the back.

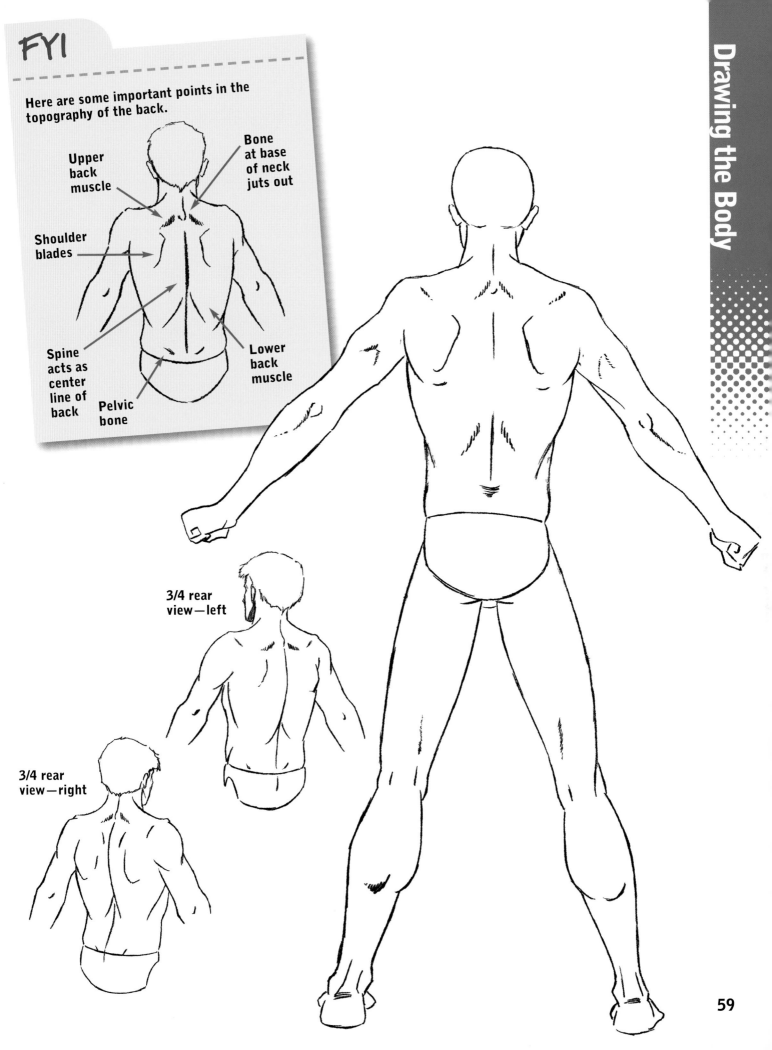

Upper back muscle

Bone at base of neck juts out

Shoulder blades

Spine acts as center line of back

Pelvic bone

Lower back muscle

3/4 rear view—left

3/4 rear view—right

Female

While I posed the male figure standing with square shoulders—which works well with an athletic figure, because it denotes strength—the female figure works better, aesthetically, when she is shifting her weight to one side or another in a more feminine pose. I'm sure you've seen this technique used in fashion illustrations. You can just feel her feminine energy in this pose—and she's not even doing anything!

Take a Hint!

The torso is dynamic. It expands and contracts as the figure shifts her weight from one side to the other.

One side bends in and becomes shorter...

...while the other s-t-r-e-t-c-h-e-s and lengthens

FYI

The spine is an S curve.

The back starts from a narrow waist and widens toward the shoulders.

The sides of the shoe curve out and back in.

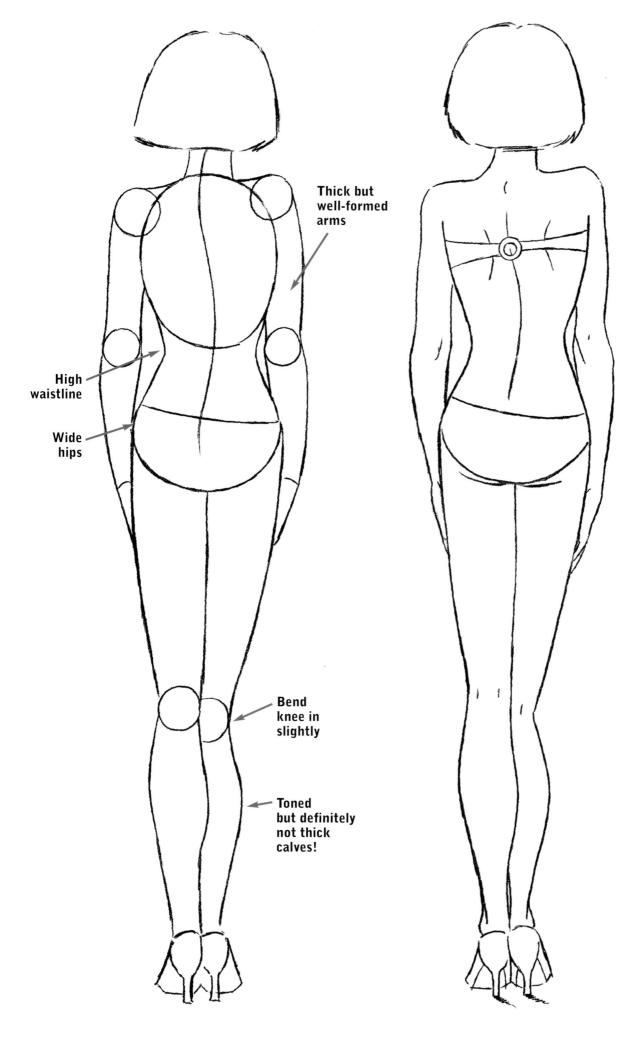

Thick but well-formed arms

High waistline

Wide hips

Bend knee in slightly

Toned but definitely not thick calves!

Construction Poses

You may finish a drawing and think, "Wow, that looks great." However, it's full of many sketch lines and eraser smudges, because it's just a first draft, so you try to redraw it.

That's where the trouble starts.

Somehow the drawing can't be duplicated. The life gets sucked out of it once you try to tighten it up. What's the matter? Was it a burst of inspiration that can't be replicated? And why not? After many years of experience, I believe I can shed some light on this problem, and even help you to solve it.

Inspiration isn't the problem. The problem is that the drawing just isn't right. The underlying construction isn't working. When you try to redraw it, you run into problems following its logic, because it isn't there. Maybe you secretly knew it in your gut, but didn't want to change it. And you worry that if you change it, the original drawing will be lost.

Maybe it will be. But maybe not.

If you really understand the mechanics of how to construct a drawing, you will only improve it by redrawing. You will add power to it, not take it away. Yes, in the beginning, you may mess up a few favorite drawings, so I recommend you trace over your drawings at first, rather than erasing.

What follows are some construction poses, to show you how drawings are broken down into their basic elements. See and feel the way they fit together, one body section into another, creating a unified whole. Practice the constructions in this section, and then we'll go on to the step-by-step finished poses in a couple of chapters.

Man Gesturing

▶ He faces in one direction, but looks back in another. The torso is drawn as one continuous shape.

Man in Relaxed Standing Pose

◀ Note how the abdominal muscles widen toward the bottom of the torso. The shoulders wedge themselves inside of the torso; they aren't just stuck onto the sides of the body.

It's All About the Torso

Once you get the concept of the rib cage and hips as two separate sections that make up the torso, you can combine them into a single uninterrupted shape. I've highlighted the torsos of these various construction poses with a thicker outline, so you can clearly see the shape. The torso is the basis for all of the full figure constructions.

Woman Standing Symmertrically

◄ When drawing women, it works well to wedge the top half of the torso firmly into the bottom half, as you might see on a storefront mannequin. That's because the waist is rather small, but the hips are wide. This is a good alternative to using an oval for the rib cage.

Woman Walking

◄ In this pose the top half of the torso remains fairly immobile, but the hips move with the stride, as indicated by the curve in the small of the back.

63

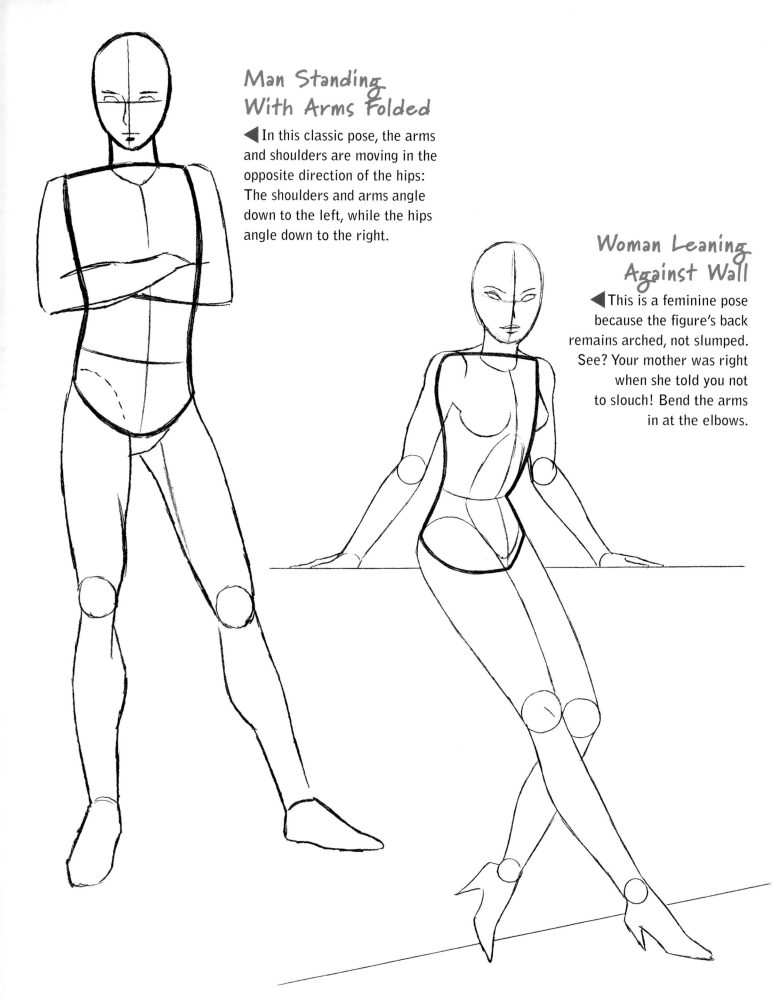

Man Standing With Arms Folded

◀ In this classic pose, the arms and shoulders are moving in the opposite direction of the hips: The shoulders and arms angle down to the left, while the hips angle down to the right.

Woman Leaning Against Wall

◀ This is a feminine pose because the figure's back remains arched, not slumped. See? Your mother was right when she told you not to slouch! Bend the arms in at the elbows.

Woman Standing With Hands Behind Back

▶ This is the classic foot position for a 3/4 pose: The near foot/leg is facing us, the viewer, while the far leg is facing sideways. The far shoulder peeks out past the collarbone.

Man Holding Briefcase

▲ The briefcase not only brings the arms in front of the body, but it also pulls the shoulders into a downward curve, and with it, the trapezius muscles (those are the muscles that connect the neck to the shoulders). That's why his shoulders look droopy.

Man Reclining

▶ By propping up his weight on his arms, he raises his shoulders above his collarbone. The hips jut forward and the feet are planted before him on the ground.

Woman Holding Purse

▶ The shoulder of the arm holding the purse is raised, but it's not part of the overall mechanics of the pose. The shoulder is moving independently, rather than acting in sync with the plane of the collarbone.

Man Standing With Hands on Hips

◄ Note the curves of his arms—
they're not just straight lines,
but feature lots of hills
and valleys caused by muscles.
As he stretches his shoulders
back, his head counterbalances
by staying straight.

Woman Sitting With Straight Leg

► This is a classic seated pose:
one leg straight out, one leg
bent. The bent leg creates a
pleasing negative space—
a triangle. And note the repeated
rhythms: a bent leg and an
extended leg, a bent arm and
an extended arm.

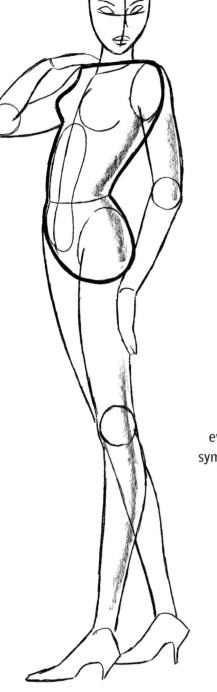

Man Standing in Rear-Facing Pose

▶ This sturdy fellow is made even stronger-looking by his totally symmetrical pose. The negative space in the crooks of the arms—which form two triangles—underscores the symmetry.

Woman Standing With Hand on Shoulder

▲ When one leg crosses behind the other, it's a graceful look. But it won't be if the far leg looks like it is in two pieces. It's best to draw the entire back leg, even if it doesn't show, to get the position right. This is called "drawing through."

Turn a Negative Into a Positive

In art, the term "negative space" refers to the space around or between objects in a drawing or painting. Many artists concentrate on the subject of a drawing, paying little attention to the negative space, but it can have a huge impact on a composition. In the drawing on the left, the triangle formed by the bent leg is a pleasing shape and adds to the beauty of the pose.

Woman Standing With Toe Pointed

◀ Standing with one toe pointed is a feminine pose. But keep in mind that this position causes the knee to bend considerably. Here's why: When the toes touch the ground, the bridge of the foot extends and lengthens the leg, causing the knee to bend.

Man Leaning Against Wall

▶ Place the supporting foot out in front so that he is basically "falling" back against the wall, which now supports his upper body. His left (bent) knee is slightly higher than his right knee.

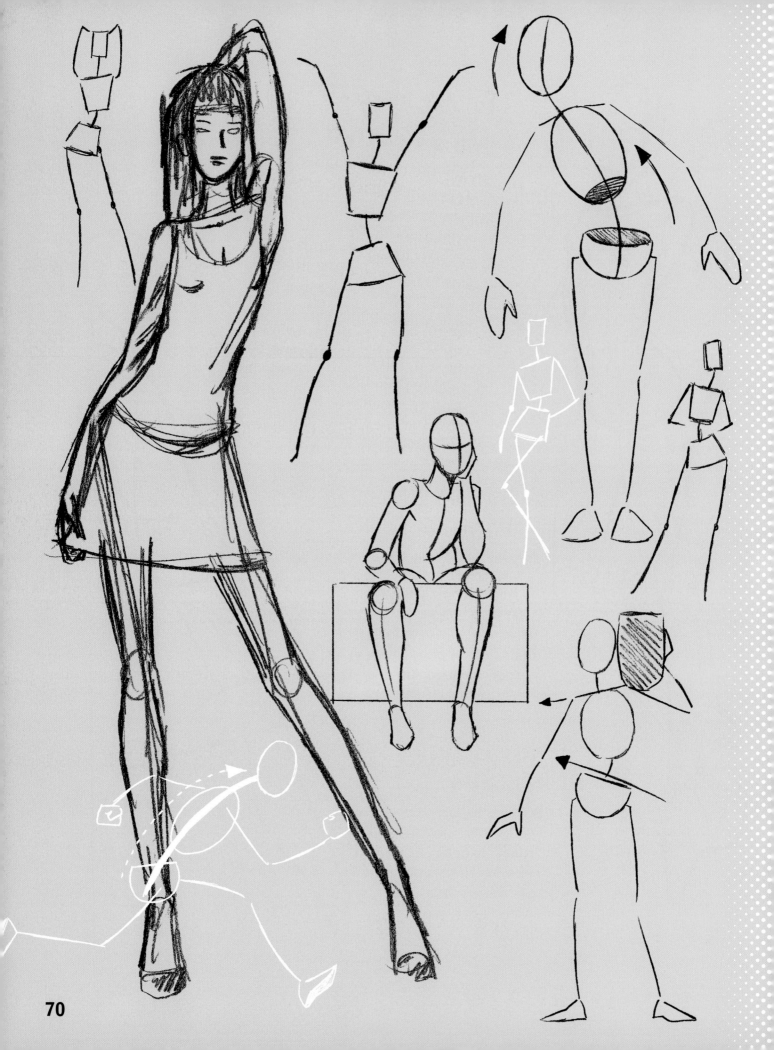

Express Yourself!
Body Dynamics

Before we plunge into drawing complete step-by-step figures, let's practice some loose sketching. Not all sketches are turned into finished drawings, in the same way that not all passages played by musicians are meant to be recorded. Sometimes, you do it just to warm up. Drawing simplified figures is also a great way to get a feel for how the body moves and expresses different feelings and emotions. Let's take a look!

Shoulder-Hip Tilt

Bodies are meant to move, bend, twist, turn. When we shift our weight, we also shift our hips to one side. The shoulders then tilt to counterbalance the hips. Then the head tilts to counterbalance the shoulders. And the spine, which is made up of many small bones and is therefore very flexible, winds itself through all of these planes: shoulder plane, hip plane and head plane. What do we get for our efforts, all this tilting back and forth? An extremely natural-looking pose.

No tilt	Hips Tilt Right	Hips Tilt Left
Neutral pose	**Hips and chest crunch together on left**	**Hips and chest crunch together on right**

When this model throws her hips to one side, she shifts her shoulders to the other to counterbalance.

Note how in 3/4 views with tilt, the blocks have dimension, or "sides," to them.

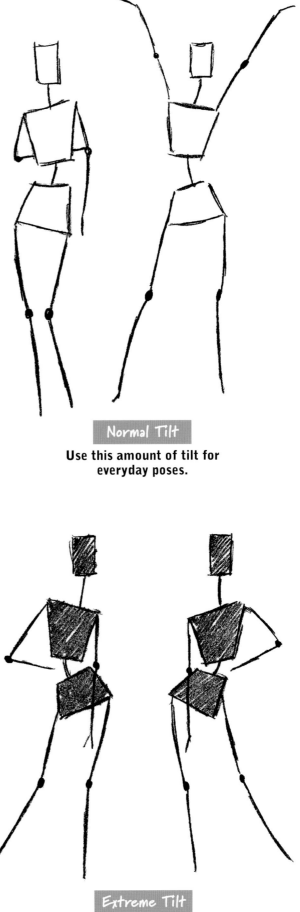

Normal Tilt

Use this amount of tilt for everyday poses.

Degrees of Tilt

Attitude and style can be expressed by varying the degree of tilt used in the hips and shoulders. The trendy style of fashion illustration is achieved to a large degree through the well-placed emphasis on shoulder-hip tilt.

Extreme Tilt

Extreme poses and fashion illustration call for extreme tilt.

Poses Using Tilt

Take a look at how the hips and shoulders tilt depending on the pose. These simple sketches show the basic direction of the tilt; the degree of tilt can be varied to customize the pose.

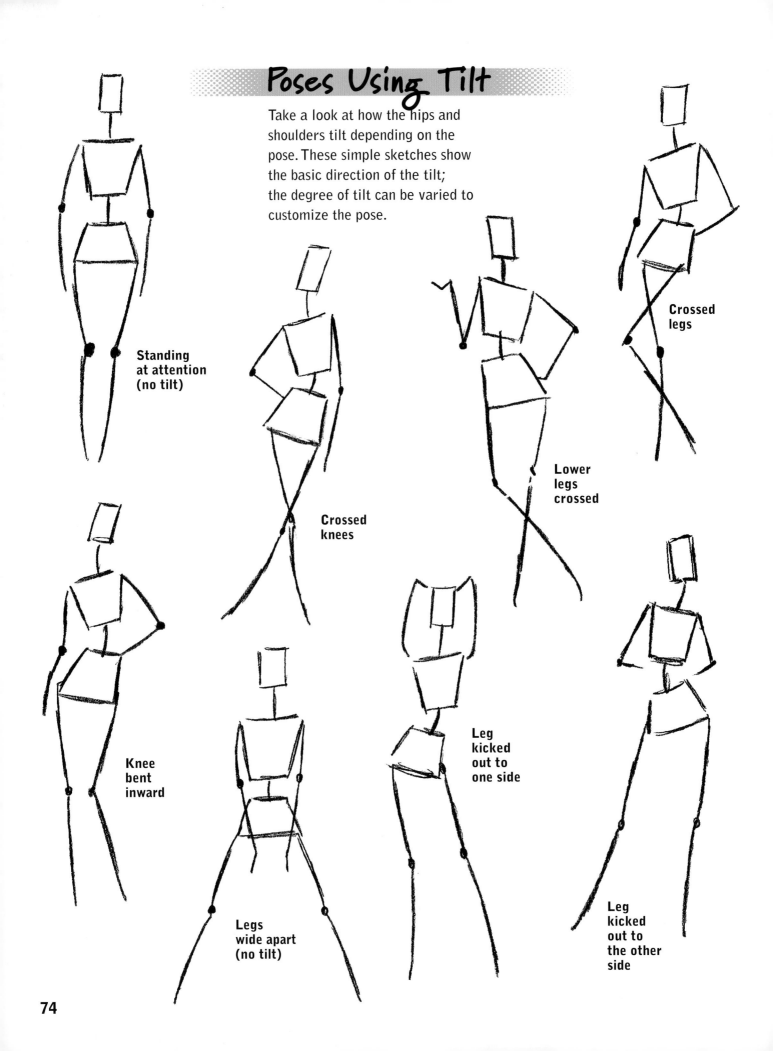

Standing at attention (no tilt)

Crossed knees

Crossed legs

Lower legs crossed

Knee bent inward

Legs wide apart (no tilt)

Leg kicked out to one side

Leg kicked out to the other side

74

The Natural Way to Stand

When standing, the rib cage and the hips naturally tilt at opposite angles from each other. This is what creates the look of the rounded tummy line, and the curve at the small of the back.

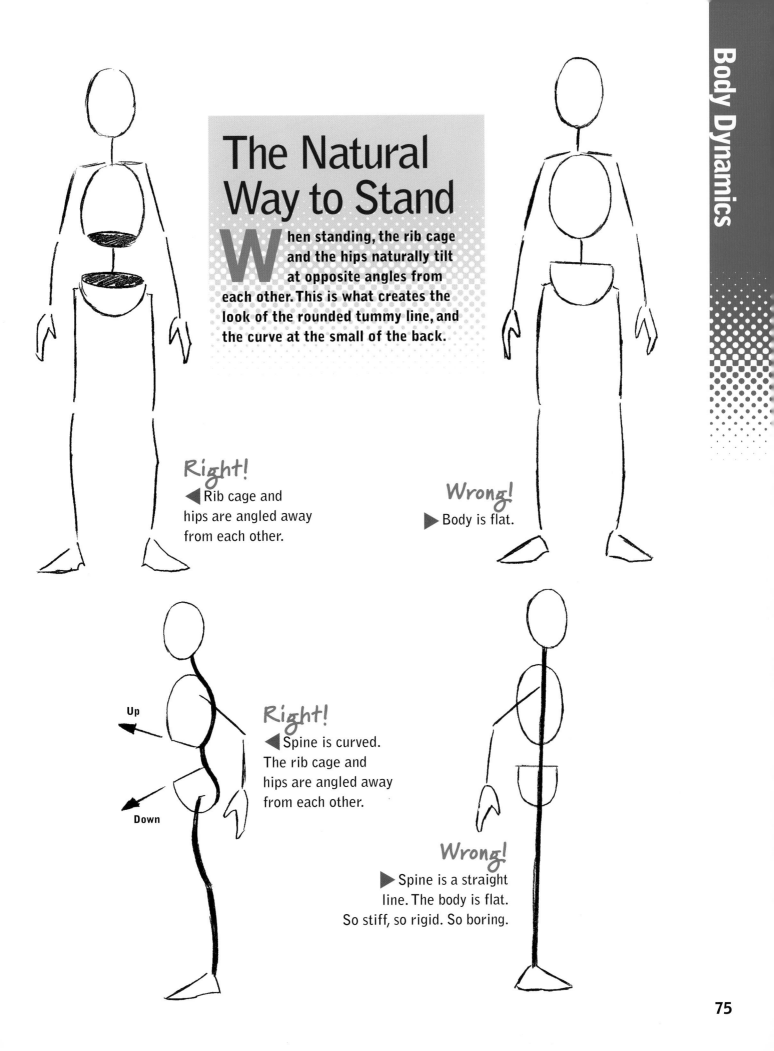

Right!
◀ Rib cage and hips are angled away from each other.

Wrong!
▶ Body is flat.

Up

Down

Right!
◀ Spine is curved. The rib cage and hips are angled away from each other.

Wrong!
▶ Spine is a straight line. The body is flat. So stiff, so rigid. So boring.

Bending

The spine, although far from being a rubber band, is much more malleable than many beginning artists realize. It give the body great flexibility.

Back and Forth

The spine can bend backward only to a limited degree (unless you're a contortionist!), but it can bend forward much farther with relative ease. Note the change in the angle of the hips as the body leans back and then bends forward.

Body bends back

Hips tilt down

Body bends forward

Hips tilt up

Side to Side

When bending from side to side, the body will try to maintain balance by bringing the center line back to the starting point—i.e., if the body moves one way, the head moves the other to get back to the center.

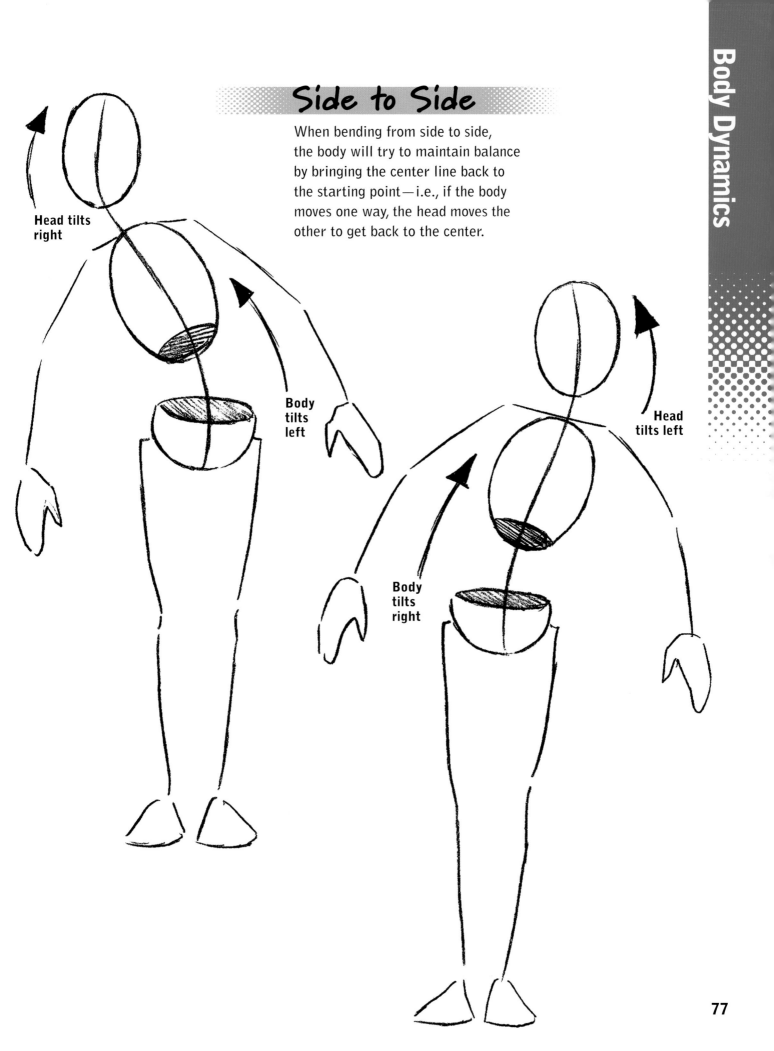

Head tilts right

Body tilts left

Head tilts left

Body tilts right

Carrying a Weight

A severe shoulder-hip tilt takes place when a person lifts something heavy, like a shopping bag or luggage. But when the lifted object is light, there is no discernable effect on the posture.

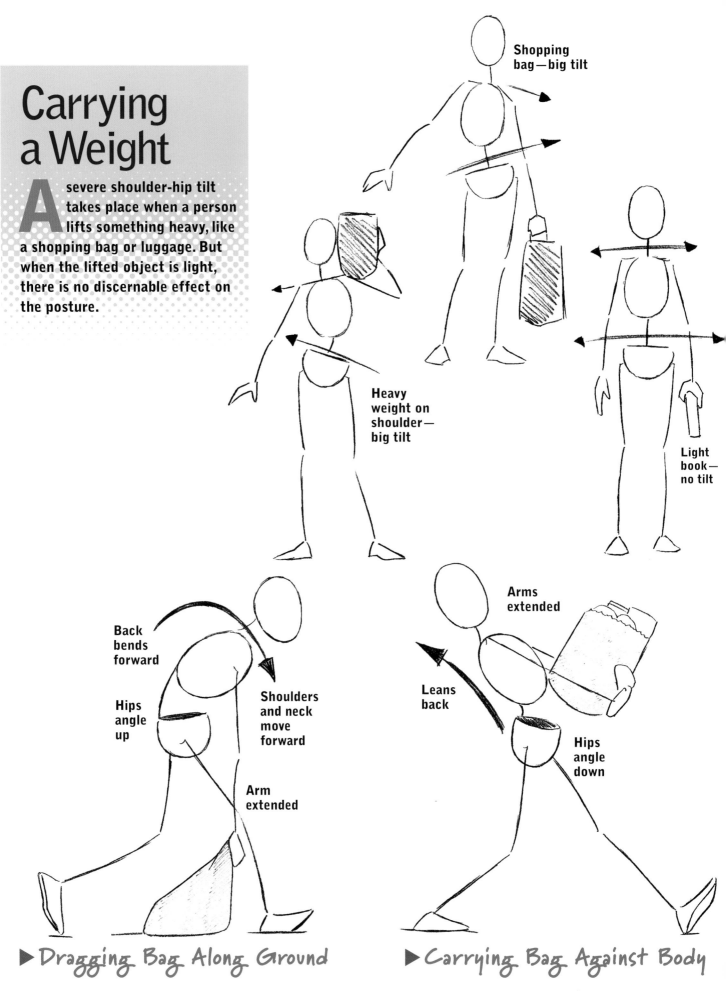

Shopping bag—big tilt

Heavy weight on shoulder— big tilt

Light book— no tilt

Back bends forward

Hips angle up

Shoulders and neck move forward

Arm extended

Arms extended

Leans back

Hips angle down

▶ Dragging Bag Along Ground

▶ Carrying Bag Against Body

78

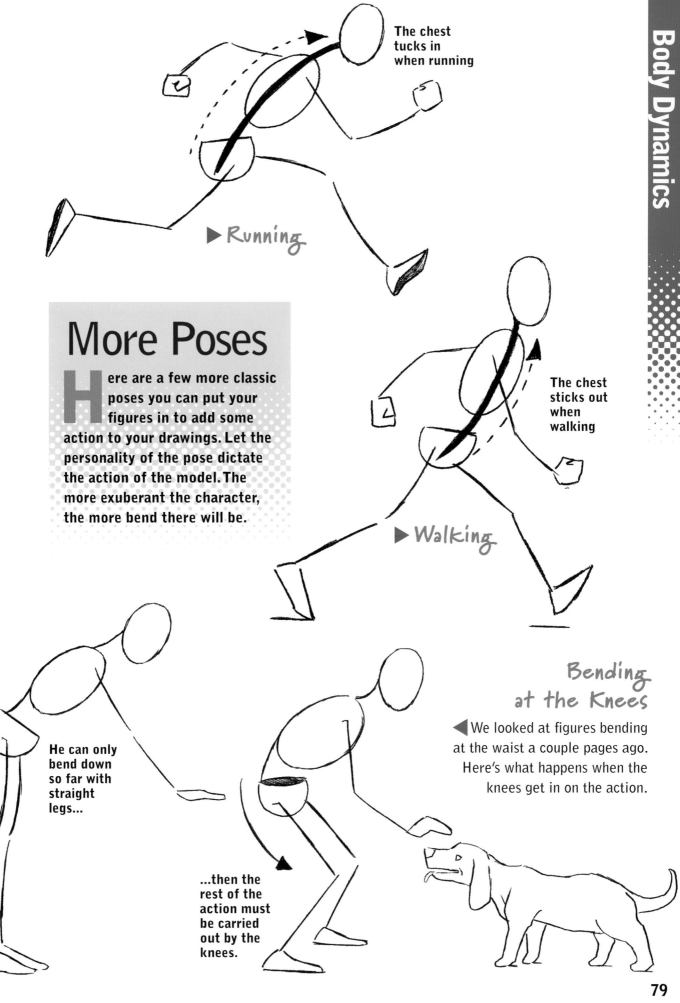

The chest tucks in when running

▶ Running

More Poses

Here are a few more classic poses you can put your figures in to add some action to your drawings. Let the personality of the pose dictate the action of the model. The more exuberant the character, the more bend there will be.

The chest sticks out when walking

▶ Walking

Bending at the Knees

◀ We looked at figures bending at the waist a couple pages ago. Here's what happens when the knees get in on the action.

He can only bend down so far with straight legs...

...then the rest of the action must be carried out by the knees.

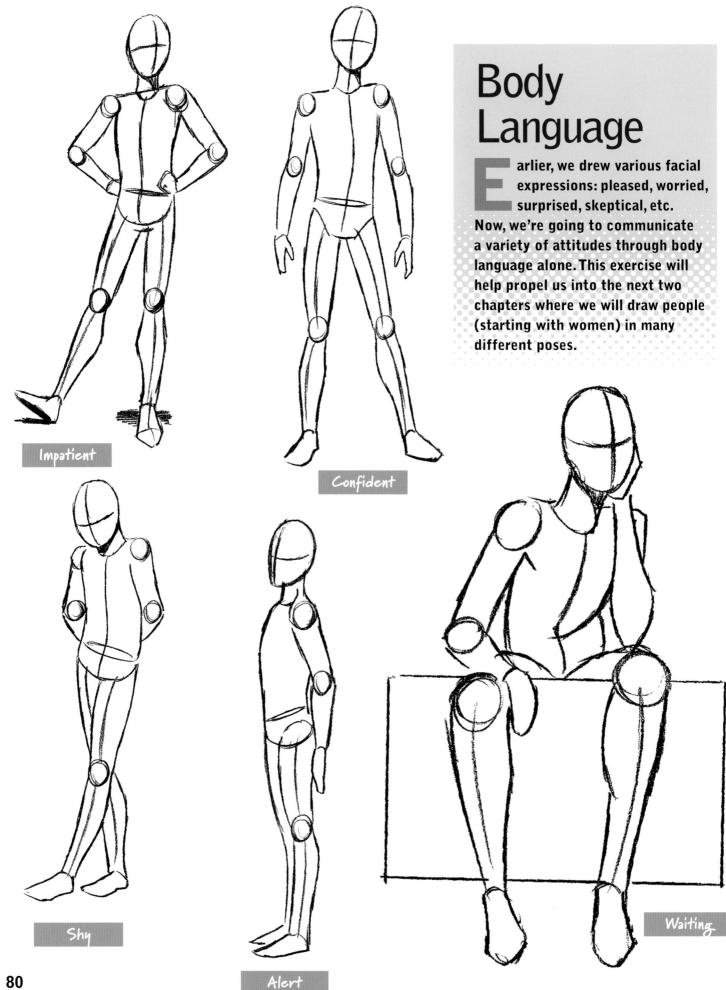

Body Language

Earlier, we drew various facial expressions: pleased, worried, surprised, skeptical, etc. Now, we're going to communicate a variety of attitudes through body language alone. This exercise will help propel us into the next two chapters where we will draw people (starting with women) in many different poses.

Impatient

Confident

Shy

Alert

Waiting

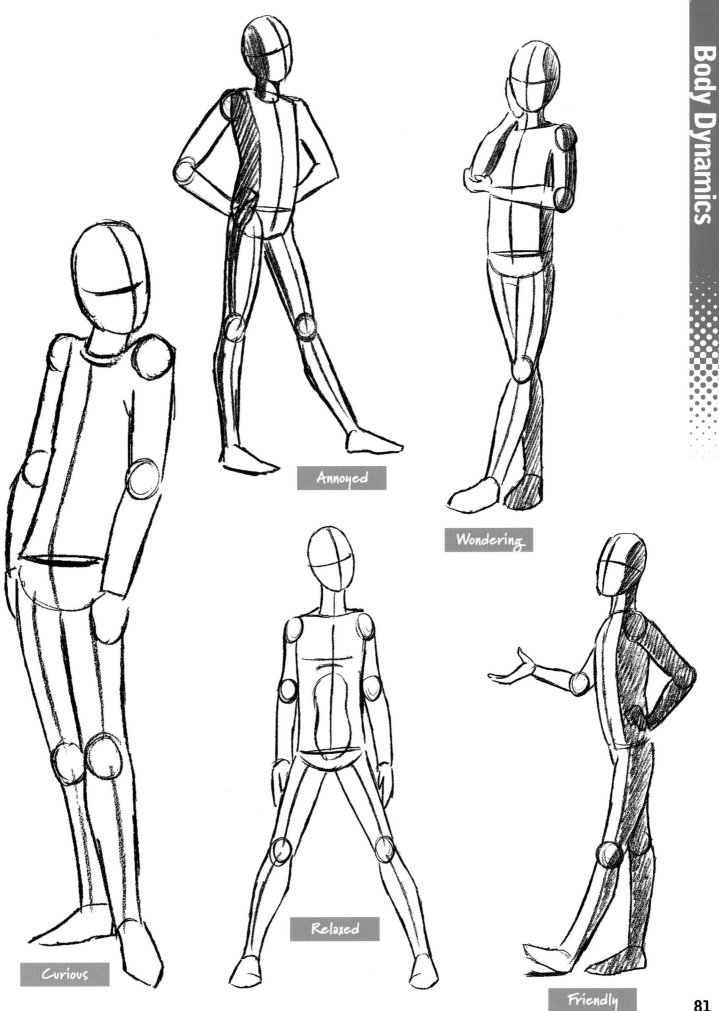

Annoyed

Wondering

Curious

Relaxed

Friendly

81

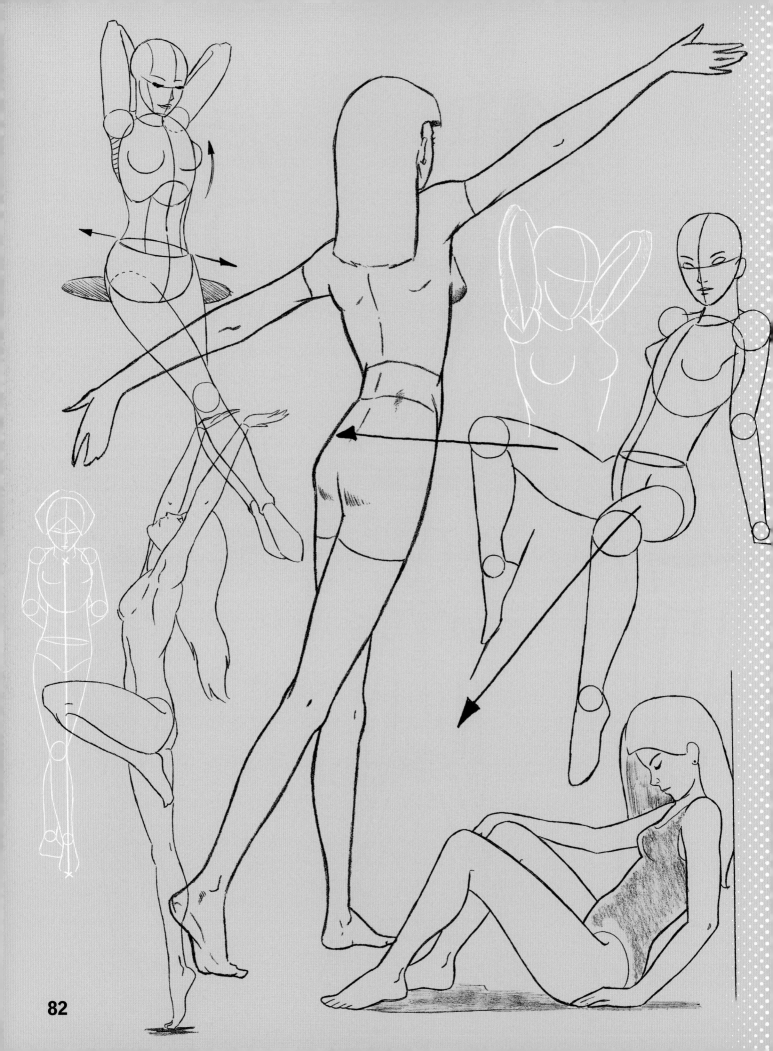

Strike a Pose!
Drawing Women

We now move on to the next phase in our ever-advancing pursuit of artistic skills: full-fledged figure drawing. But, so you don't get lost, we're going to go step by step and there will be plenty of hints to help you out along the way. First, we'll cover female models in a wide variety of appealing poses, and then move on to male models in the next chapter. You are, like, so ready it's unbelievable.

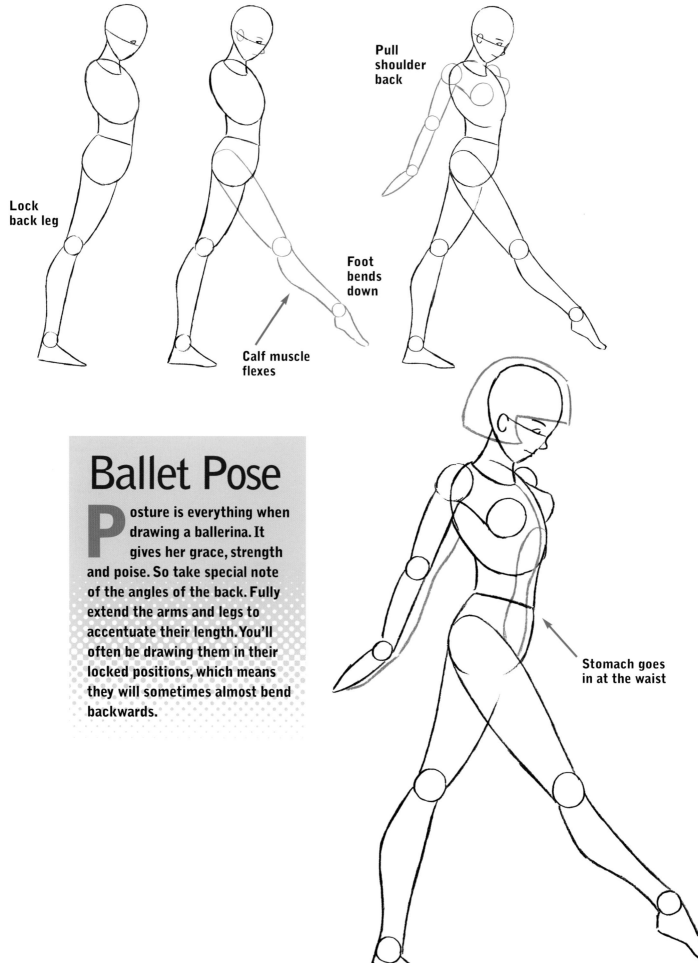

Lock back leg

Pull shoulder back

Calf muscle flexes

Foot bends down

Ballet Pose

Posture is everything when drawing a ballerina. It gives her grace, strength and poise. So take special note of the angles of the back. Fully extend the arms and legs to accentuate their length. You'll often be drawing them in their locked positions, which means they will sometimes almost bend backwards.

Stomach goes in at the waist

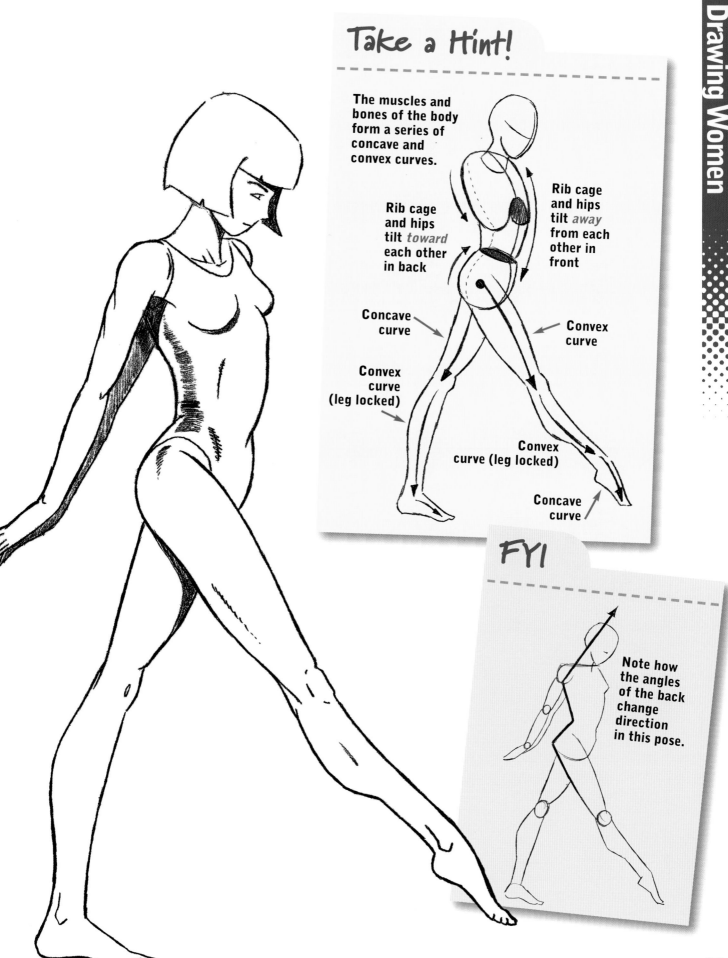

Take a Hint!

The muscles and bones of the body form a series of concave and convex curves.

Rib cage and hips tilt *toward* each other in back

Rib cage and hips tilt *away* from each other in front

Concave curve

Convex curve

Convex curve (leg locked)

Convex curve (leg locked)

Concave curve

FYI

Note how the angles of the back change direction in this pose.

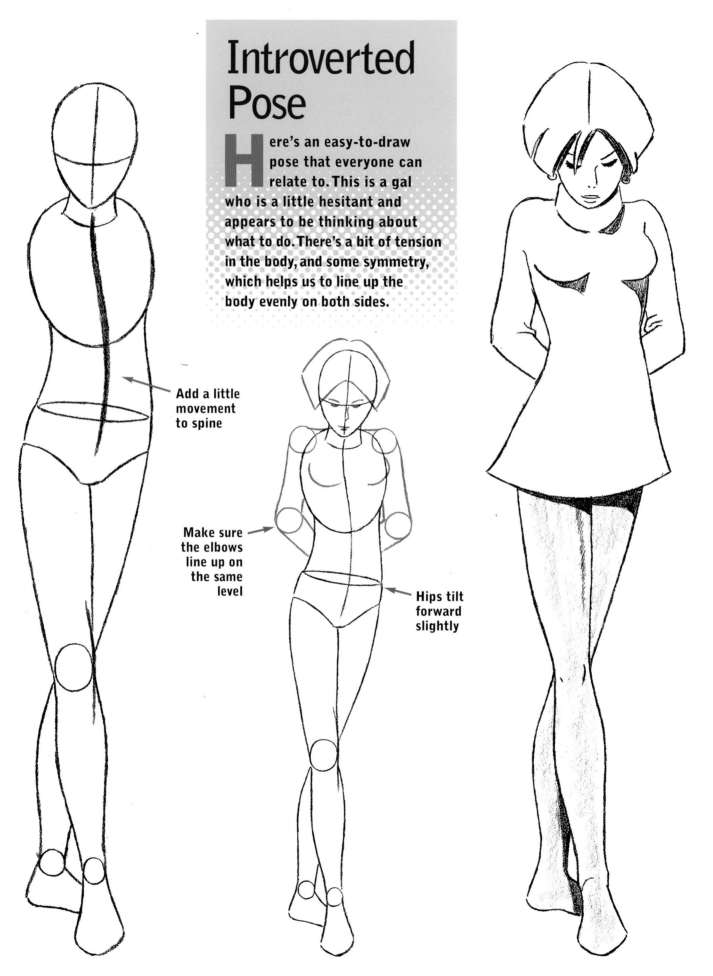

Introverted Pose

Here's an easy-to-draw pose that everyone can relate to. This is a gal who is a little hesitant and appears to be thinking about what to do. There's a bit of tension in the body, and some symmetry, which helps us to line up the body evenly on both sides.

Add a little movement to spine

Make sure the elbows line up on the same level

Hips tilt forward slightly

Take a Hint!

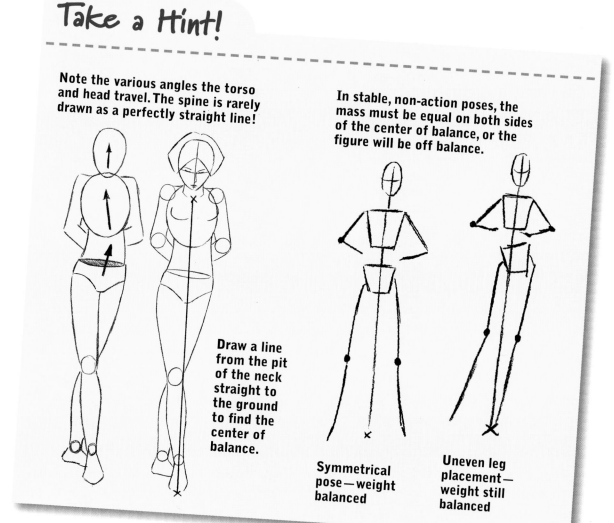

Note the various angles the torso and head travel. The spine is rarely drawn as a perfectly straight line!

Draw a line from the pit of the neck straight to the ground to find the center of balance.

In stable, non-action poses, the mass must be equal on both sides of the center of balance, or the figure will be off balance.

Symmetrical pose—weight balanced

Uneven leg placement—weight still balanced

Figures wearing formfitting clothes, like these leggings, are sometimes the easiest to draw, because you only have to draw the body once. For figures with looser clothes, you have to draw the underlying body first, then draw the clothes with all their folds and creases on top.

FYI

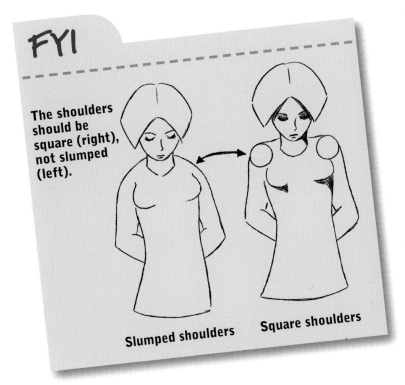

The shoulders should be square (right), not slumped (left).

Slumped shoulders

Square shoulders

Athletic Pose

As you can probably tell by now, I like to draw the arms and legs extended in female poses. Don't get me wrong—I feature lots of bent knees and elbows, too. But for aesthetics, I believe you can't beat the grace of the female form with long legs and arms in a pose. Bent, inward-turning arms and legs tend to look awkward.

Oval-shaped rib cage

Square off kneecap

Create a flowing line from toes up to neck

Draw arms through head (don't worry, you can erase later!)

Line of shoulder muscle

Line of back muscle

Calf muscle flexes

Take a Hint!

The upper and lower arms are *not* exactly the same length.

The upper and lower legs *are* the same length.

Slightly longer

Slightly shorter

Equal

Equal

FYI

Bust protrudes with arms down

The outline of the breast changes depending on the position of the arms.

Bust flattens out when arms rise above head

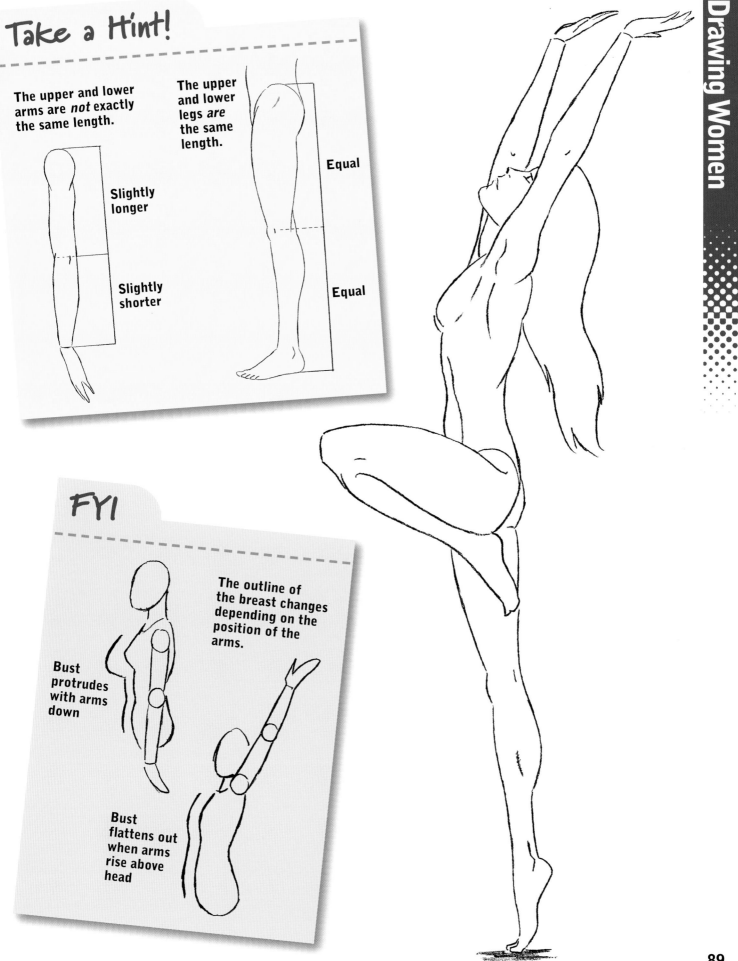

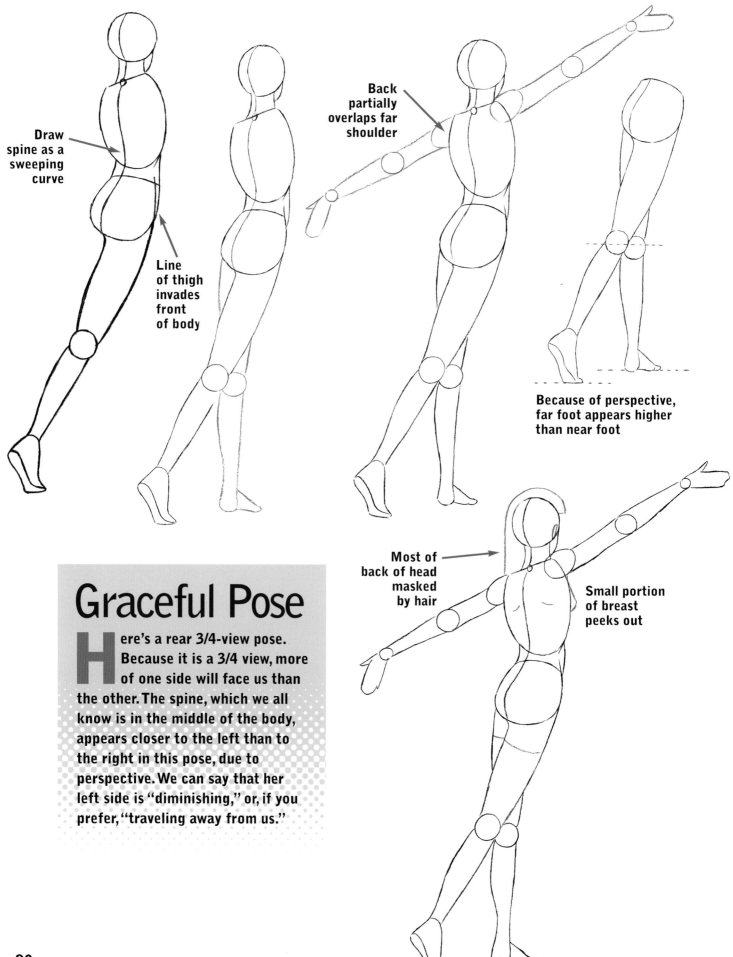

Draw spine as a sweeping curve

Line of thigh invades front of body

Back partially overlaps far shoulder

Because of perspective, far foot appears higher than near foot

Most of back of head masked by hair

Small portion of breast peeks out

Graceful Pose

Here's a rear 3/4-view pose. Because it is a 3/4 view, more of one side will face us than the other. The spine, which we all know is in the middle of the body, appears closer to the left than to the right in this pose, due to perspective. We can say that her left side is "diminishing," or, if you prefer, "traveling away from us."

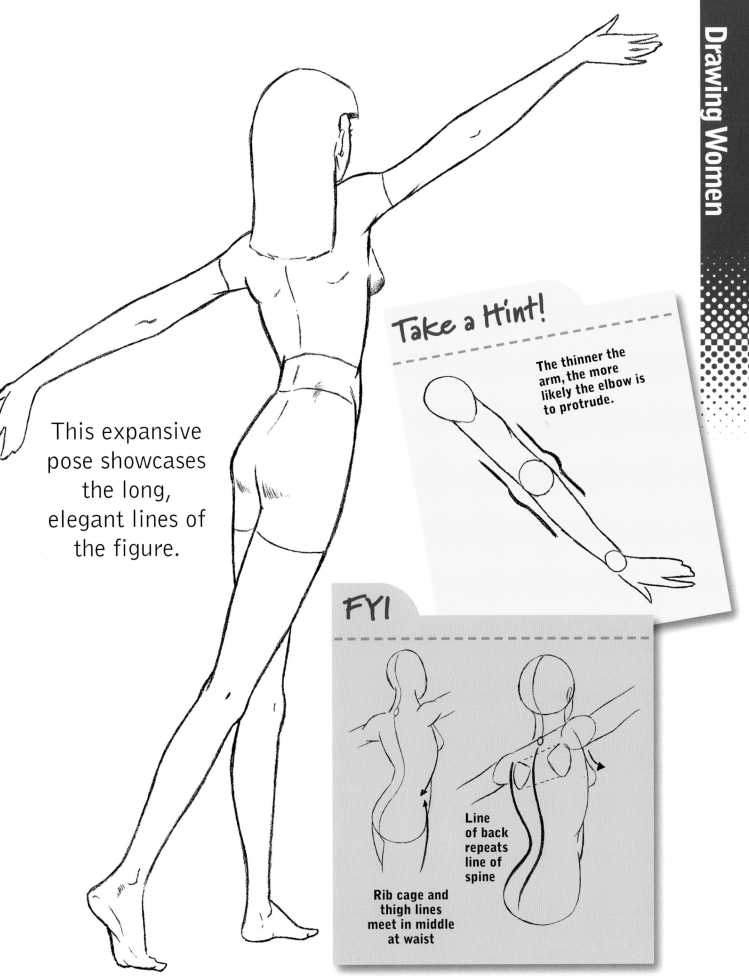

This expansive pose showcases the long, elegant lines of the figure.

Take a Hint!

The thinner the arm, the more likely the elbow is to protrude.

FYI

Rib cage and thigh lines meet in middle at waist

Line of back repeats line of spine

Hands on Head

This pose brings into play the shoulder, chest and biceps muscles. In addition, the entire outline of her body is visible; nothing is hidden behind an arm, or behind a partially turned back. We have to make sure our form is correct, and that means a good, basic construction. Note how the back muscles (on the sides of the figure) widen out and appear to merge into the shoulder muscles.

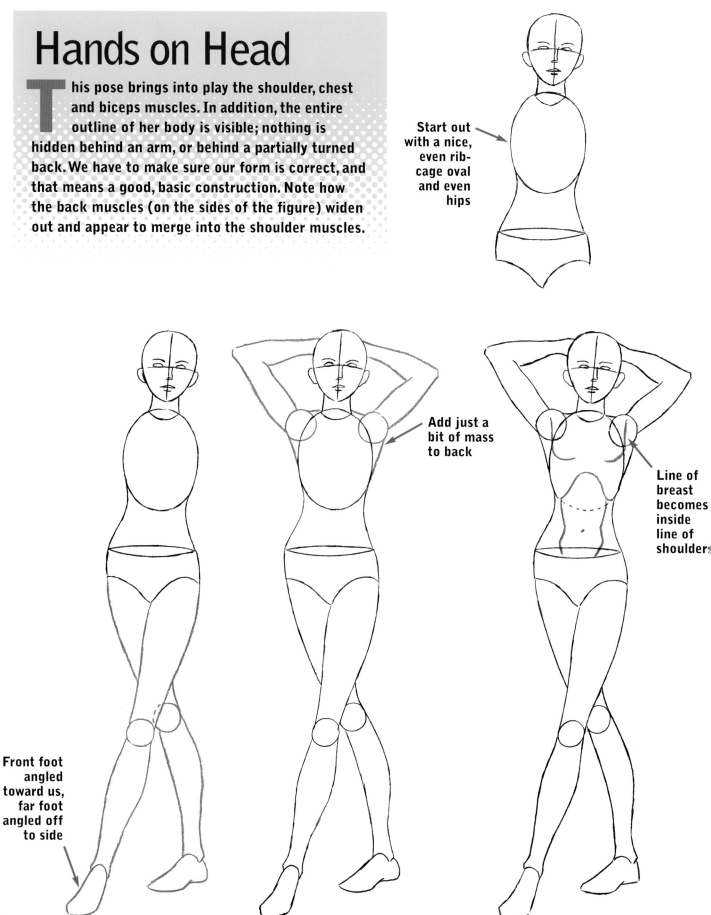

Start out with a nice, even rib-cage oval and even hips

Add just a bit of mass to back

Line of breast becomes inside line of shoulders

Front foot angled toward us, far foot angled off to side

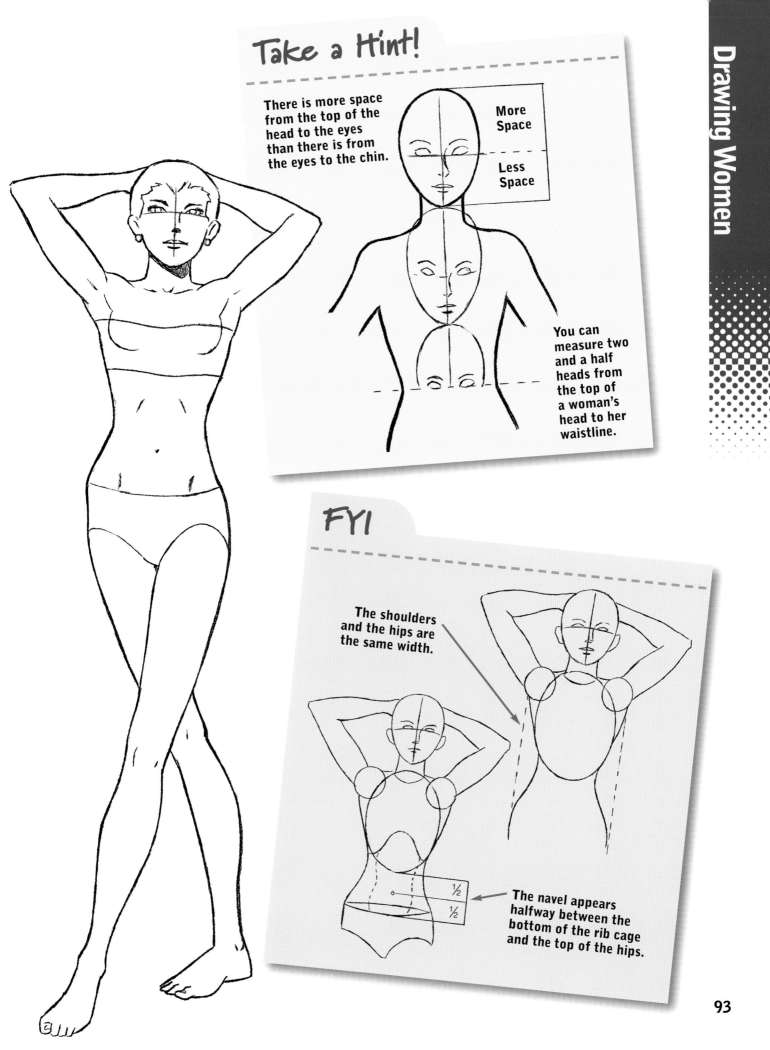

Take a Hint!

There is more space from the top of the head to the eyes than there is from the eyes to the chin.

More Space

Less Space

You can measure two and a half heads from the top of a woman's head to her waistline.

FYI

The shoulders and the hips are the same width.

½
½

The navel appears halfway between the bottom of the rib cage and the top of the hips.

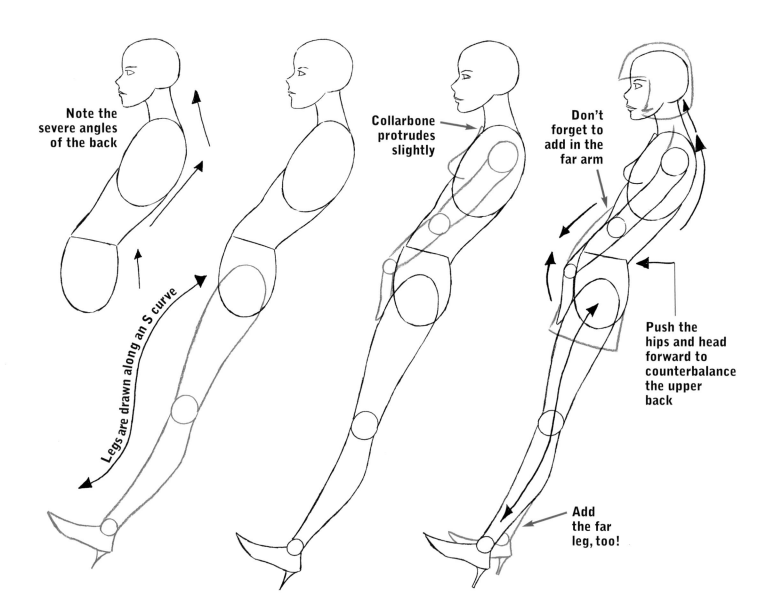

Note the severe angles of the back

Legs are drawn along an S curve

Collarbone protrudes slightly

Don't forget to add in the far arm

Push the hips and head forward to counterbalance the upper back

Add the far leg, too!

Leaning Against Wall

I'm not even going to guess how much she paid for that haircut. But it's more than she paid for those shoes, and those weren't cheap! Here's a contradictory pose: an elongated, slinky body that is tensed up, in order to lean at a 45-degree angle. There are a lot of body dynamics going on here, which make for an interesting pose.

Remember that even though the thighs are thickest at the top, they go inside of the hips, and that the hips are wider.

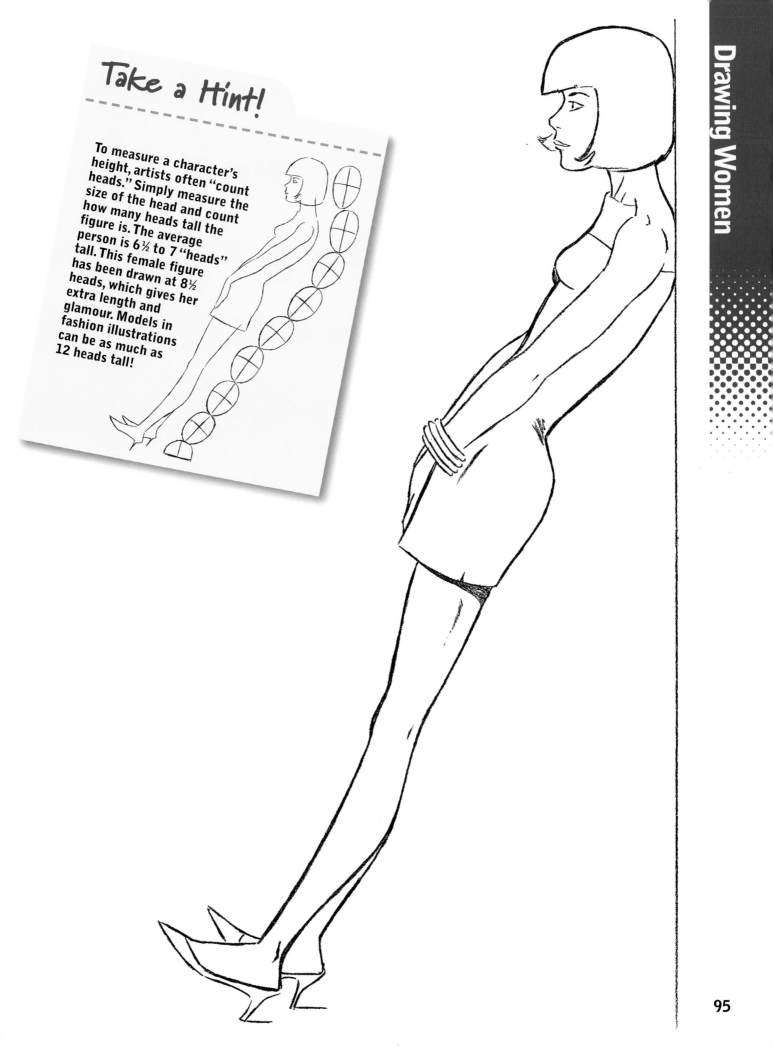

Take a Hint!

To measure a character's height, artists often "count heads." Simply measure the size of the head and count how many heads tall the figure is. The average person is 6 ½ to 7 "heads" tall. This female figure has been drawn at 8 ½ heads, which gives her extra length and glamour. Models in fashion illustrations can be as much as 12 heads tall!

Standing 3/4 View

To define the angle at which this dancer is facing, draw the center line close to the far edge of the body. Be sure the center line follows the contour of the tummy as it continues from the pit of the neck down to the crotch. Her head is also drawn in a 3/4 view.

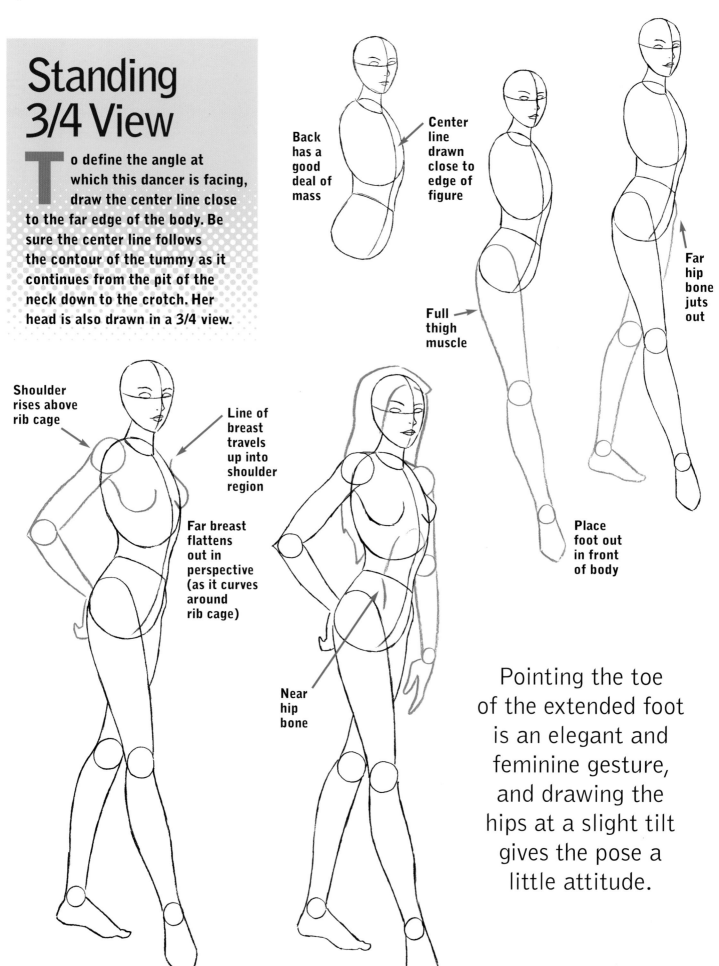

Back has a good deal of mass

Center line drawn close to edge of figure

Full thigh muscle

Far hip bone juts out

Place foot out in front of body

Shoulder rises above rib cage

Line of breast travels up into shoulder region

Far breast flattens out in perspective (as it curves around rib cage)

Near hip bone

Pointing the toe of the extended foot is an elegant and feminine gesture, and drawing the hips at a slight tilt gives the pose a little attitude.

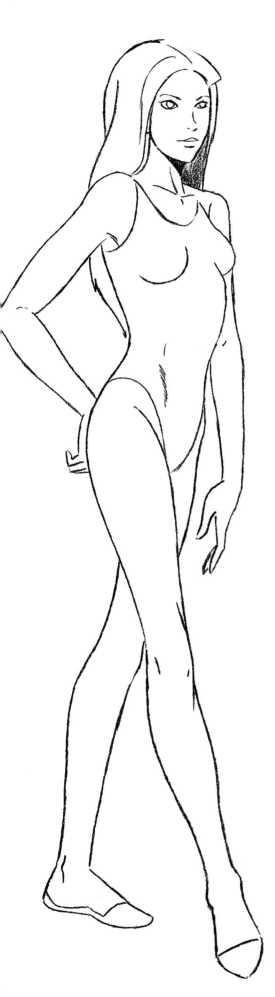

FYI

Both shoulders are pulled up in this purposeful pose.

Artists sometimes draw horizontal lines that follow the contours of the body to remind themselves—and their students—that they are drawing a three-dimensional object.

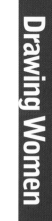

Take a Hint!

In the 3/4 view, one side of the figure is facing the viewer.

Holding the head slightly forward is a more natural position, but our dancer is emphasizing poise by holding her head up straight.

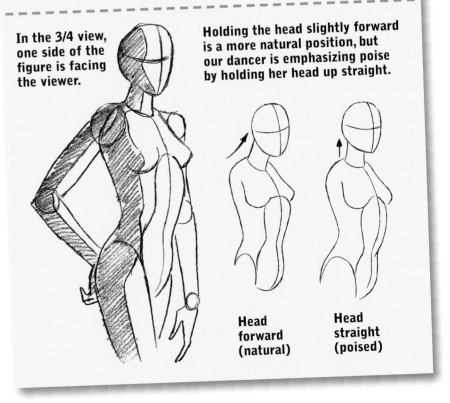

Head forward (natural)

Head straight (poised)

Backward Glance

It's often said that you shouldn't place a figure's hands in her pockets, because it looks like you're avoiding drawing them. That may be true. However, it's ridiculous to avoid it at all costs, because people really do place their hands in their pockets. And there are many expressive poses, such as this one, that require it.

Take a Hint!

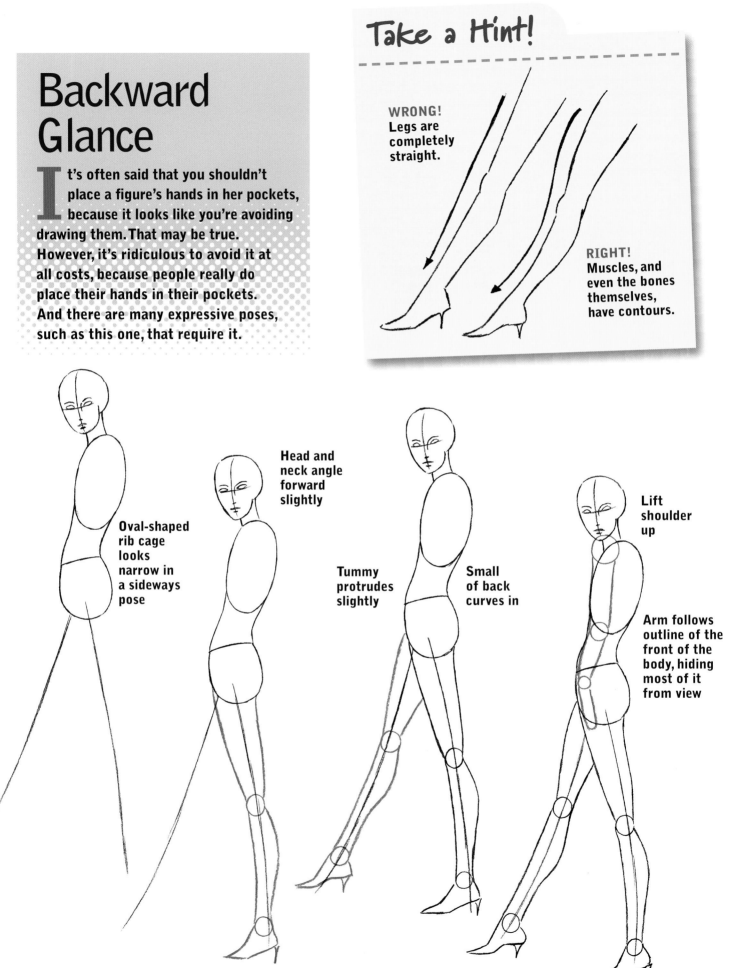

WRONG! Legs are completely straight.

RIGHT! Muscles, and even the bones themselves, have contours.

Oval-shaped rib cage looks narrow in a sideways pose

Head and neck angle forward slightly

Tummy protrudes slightly

Small of back curves in

Lift shoulder up

Arm follows outline of the front of the body, hiding most of it from view

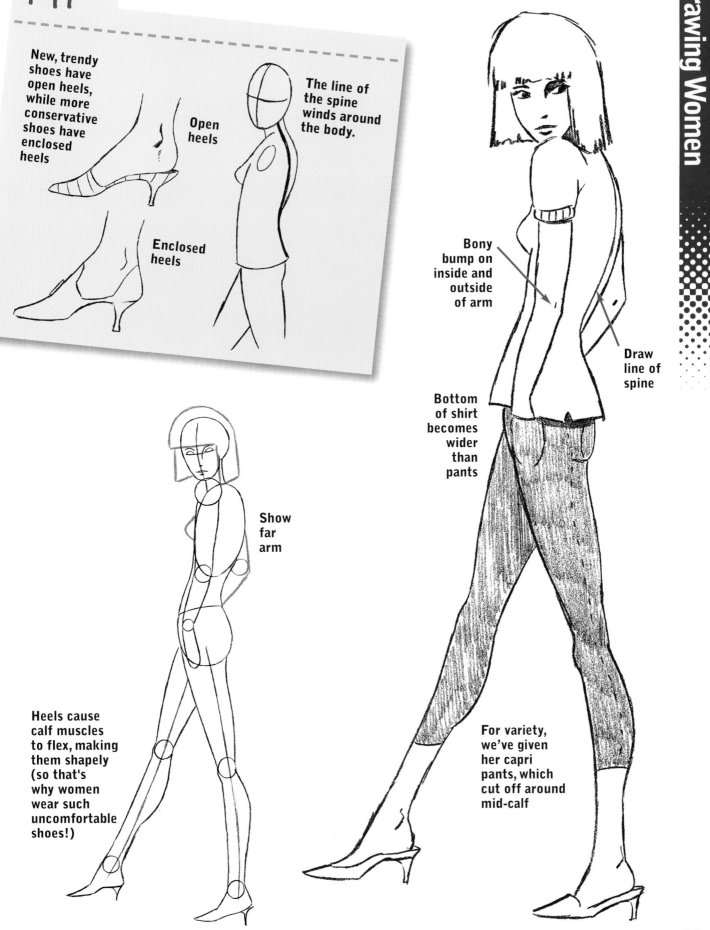

FYI

New, trendy shoes have open heels, while more conservative shoes have enclosed heels

Open heels

Enclosed heels

The line of the spine winds around the body.

Bony bump on inside and outside of arm

Draw line of spine

Bottom of shirt becomes wider than pants

Show far arm

Heels cause calf muscles to flex, making them shapely (so that's why women wear such uncomfortable shoes!)

For variety, we've given her capri pants, which cut off around mid-calf

On the Move

Drawing the back leg lifted slightly off the ground gives the impression that she's in the middle of a fast walk, or even a light run. As she skips forward, she arches her back, as if dragging a half-beat behind, which gives the pose a feeling of forward momentum. The body works like a set of dominoes: One section begins an action, and the rest quickly falls into line. In animation, this is called "secondary action." It creates a pleasing flow, or "line of action."

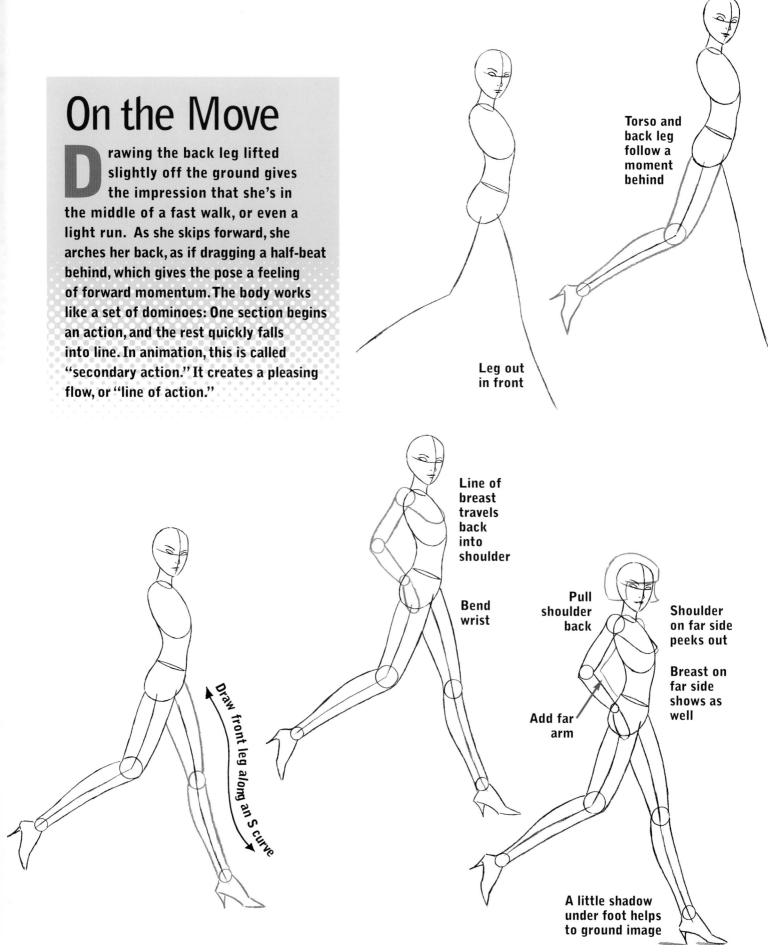

Torso and back leg follow a moment behind

Leg out in front

Draw front leg along an S curve

Line of breast travels back into shoulder

Bend wrist

Pull shoulder back

Add far arm

Shoulder on far side peeks out

Breast on far side shows as well

A little shadow under foot helps to ground image

Take a Hint!

The far "knob" of the collarbone can be seen peeking out from the other side.

The "line of action" represents the general direction of the pose.

FYI

Flexing the bent leg causes the muscles in the back of the thigh, called the "leg biceps" to bunch. Straightening the leg flattens the muscles

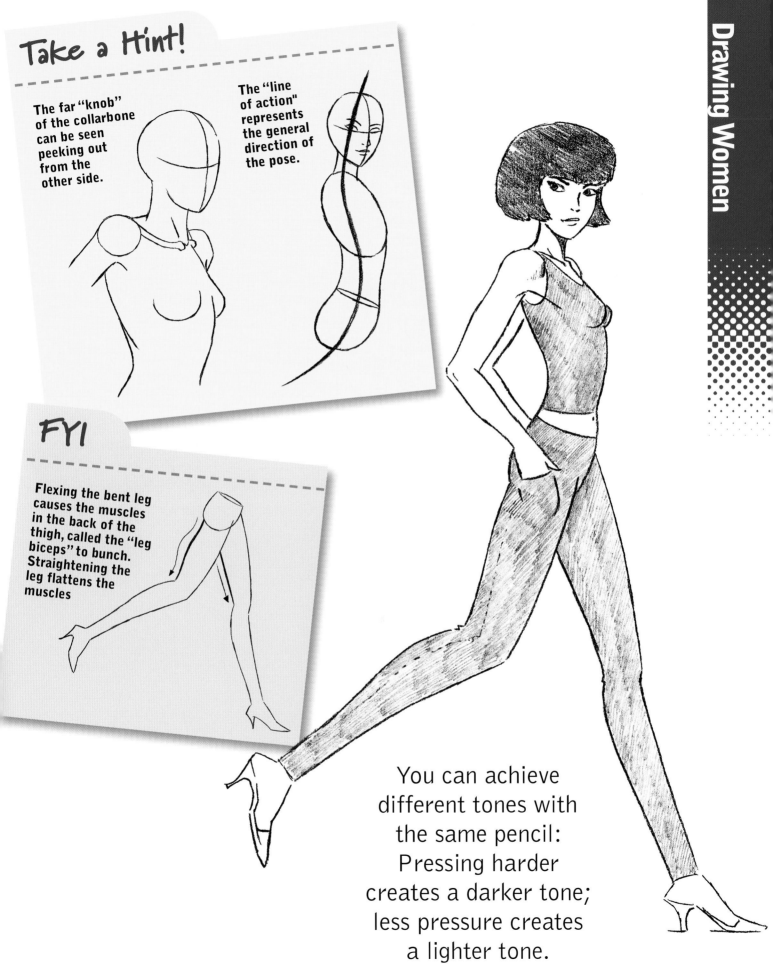

You can achieve different tones with the same pencil: Pressing harder creates a darker tone; less pressure creates a lighter tone.

Kneeling on Stool

Now we'll move on to a few kneeling and sitting poses. The tricky part of drawing these foreshortened positions is that the bent leg is in danger of looking too short or too long. It must be the same length as the straight leg. In many seated positions, perspective warps the length, so that it's impossible to give a definitive rule to follow, such as "the bent leg is three hand-lengths long," etc.

This pose, however, is a strict side view, so it shows no perspective at all and therefore is easier to measure. Just compare one to the other and make sure they are the same length. Simple!

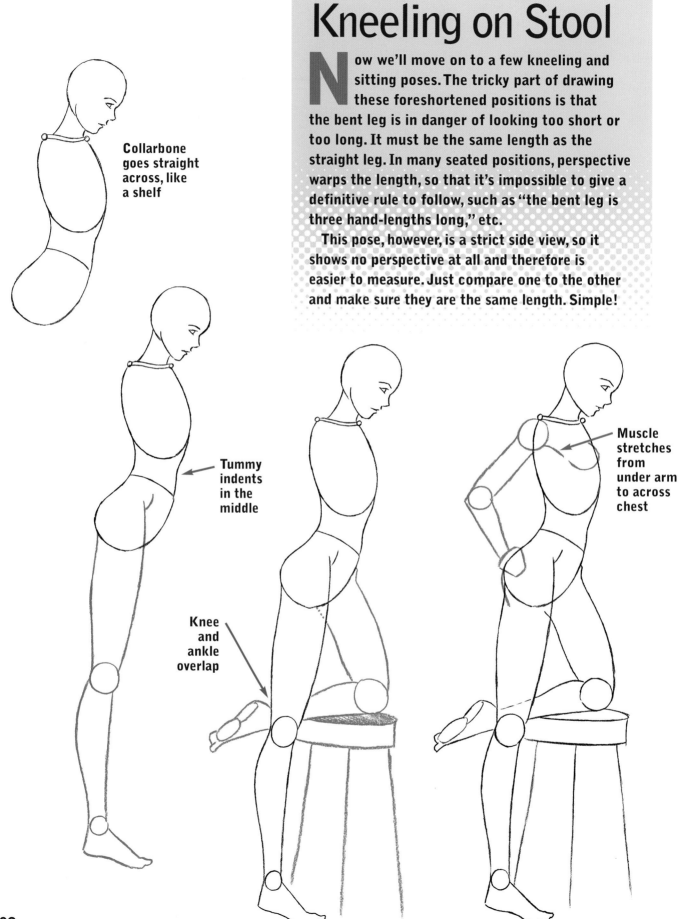

Collarbone goes straight across, like a shelf

Tummy indents in the middle

Knee and ankle overlap

Muscle stretches from under arm to across chest

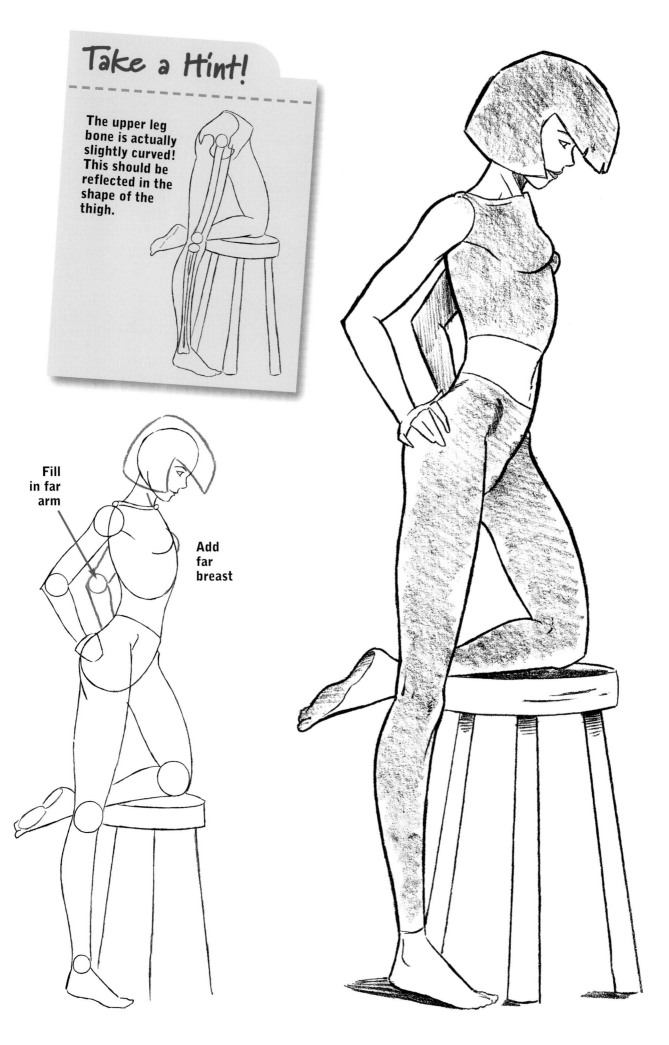

Take a Hint!

The upper leg bone is actually slightly curved! This should be reflected in the shape of the thigh.

Fill in far arm

Add far breast

Seated 3/4 Pose

When an object angles toward you, like the near thigh in this drawing, it appears to get shorter. This is called foreshortening. The far thigh, which is not coming toward us, remains at full length. Beginners sometimes get nervous drawing foreshortened limbs, worrying that they will look "wrong" if they compress them too much. I'm here to give you permission to go ahead and shorten the heck out of them. It will look right.

The line of action of this pose is a sweeping S curve

Far thigh travels sideways and remains at full length

Calf, which travels down, not toward us, remains at full length

Near thigh travels toward us and appears shorter due to perspective

Take a Hint!

Here are a few tips for drawing the foreshortened thigh.

The hyperextended elbow appears to bend almost backward.

Severely round off this area

Draw knee as enlarged sphere

Line of calf invades thigh area...

...and ankle

Sitting With Legs Entwined

This is a typical, but exclusively feminine pose. Guys would pull a muscle just trying to get into this position! It's absolutely essential, in this pose, to draw through the near leg in order to arrive at the correct position for the far leg.

Interlaced legs are a pleasing look because they create their own S curve.

Torso leans slightly forward, bent over at waist

Hips sit upright and even

Draw through near leg to find correct placement of far leg

FYI

One foot points down while the other hooks up.

Foot of near leg points down

Foot of far leg hooks up

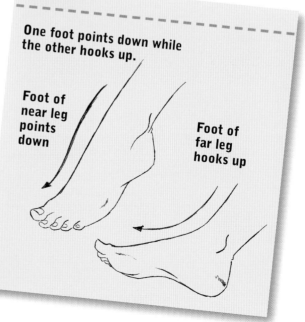

Seated on Both Knees

Here's a pose with a very clean line of action—a single curved line arching through the back. The near leg is foreshortened, because it is angled toward us. But the far leg is not foreshortened, because it is traveling to the side (neutral). The arms, too, are neutral, because they are traveling up and down in the picture plane, not from foreground to background.

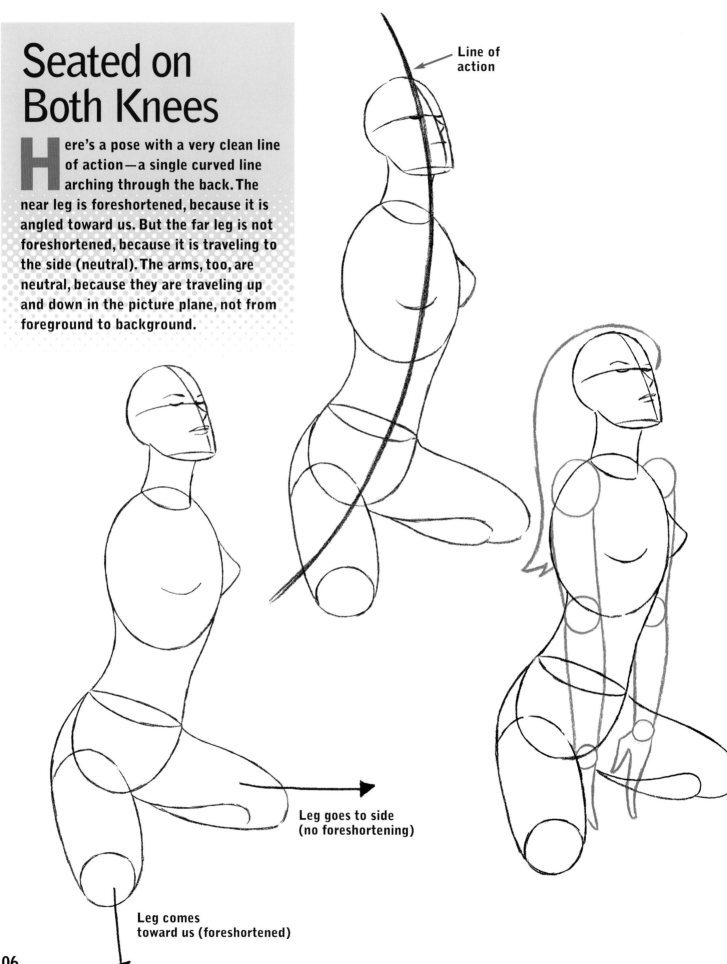

Line of action

Leg goes to side
(no foreshortening)

Leg comes
toward us (foreshortened)

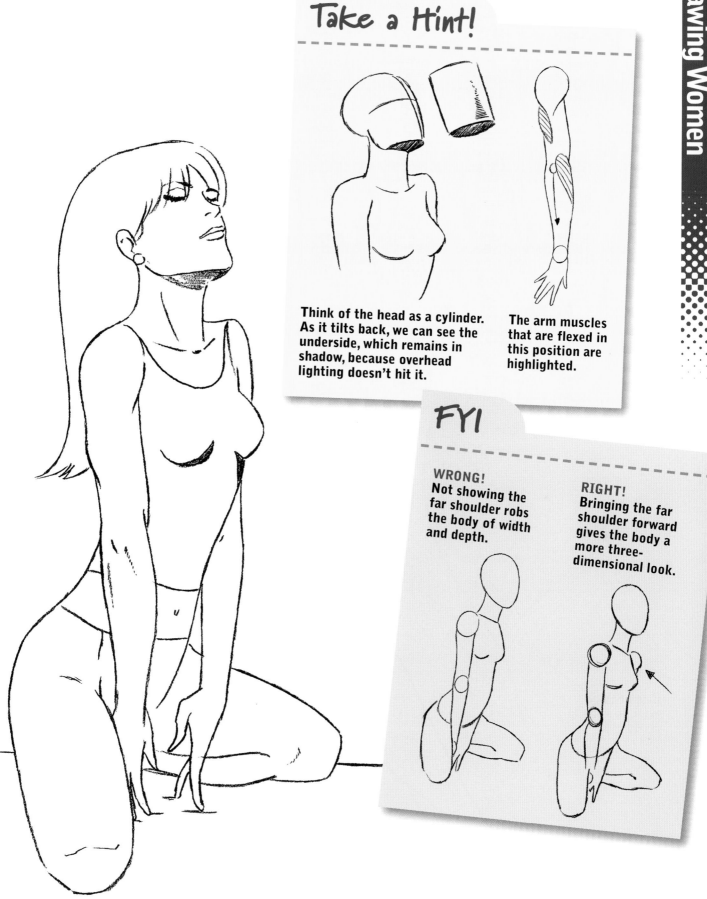

Take a Hint!

Think of the head as a cylinder. As it tilts back, we can see the underside, which remains in shadow, because overhead lighting doesn't hit it.

The arm muscles that are flexed in this position are highlighted.

FYI

WRONG!
Not showing the far shoulder robs the body of width and depth.

RIGHT!
Bringing the far shoulder forward gives the body a more three-dimensional look.

Sitting Propped Up

This pose features several different angles: The head, torso and hips are all tilting in different directions. Use a strong line of action running through the torso and head to simplify and unify it.

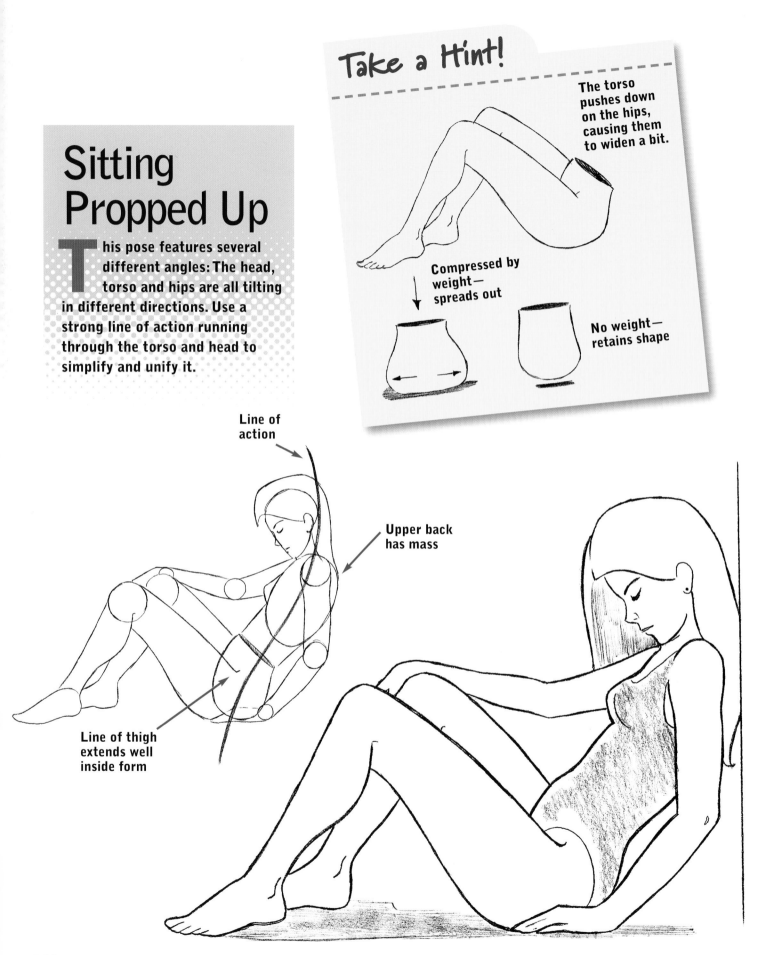

Take a Hint!

The torso pushes down on the hips, causing them to widen a bit.

Compressed by weight— spreads out

No weight— retains shape

Line of action

Upper back has mass

Line of thigh extends well inside form

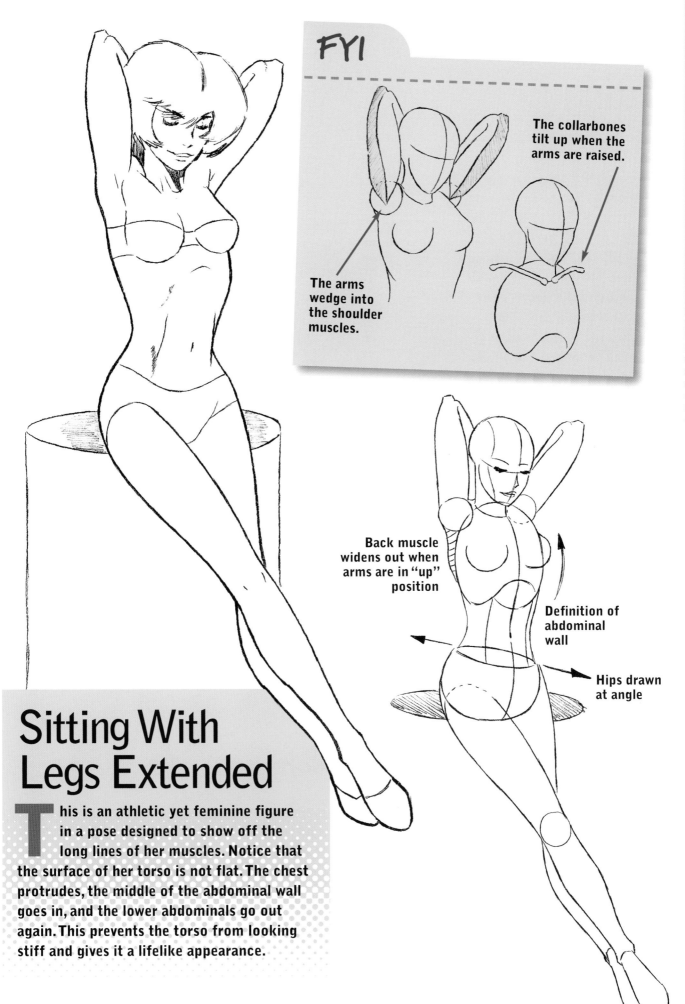

FYI

The collarbones tilt up when the arms are raised.

The arms wedge into the shoulder muscles.

Back muscle widens out when arms are in "up" position

Definition of abdominal wall

Hips drawn at angle

Sitting With Legs Extended

This is an athletic yet feminine figure in a pose designed to show off the long lines of her muscles. Notice that the surface of her torso is not flat. The chest protrudes, the middle of the abdominal wall goes in, and the lower abdominals go out again. This prevents the torso from looking stiff and gives it a lifelike appearance.

Sitting on Stool

This seated pose is really more of an action drawing because of all of the body dynamics at work here. The hips and the rib cage twist in opposite directions. The line of the spine snakes around the figure, like stripes on a candy cane. The downward tilt of the head, as it turns back to look at the viewer, also adds a nice touch.

Downsize It!

You may be surprised to hear me say that both legs are drawn in perspective here. What do I mean? The legs are not foreshortened, as in earlier examples we've seen. They're not coming at us, or getting bigger. They're traveling away from us and therefore getting smaller. When an object travels toward you or away from you, it must be exaggerated or diminished.

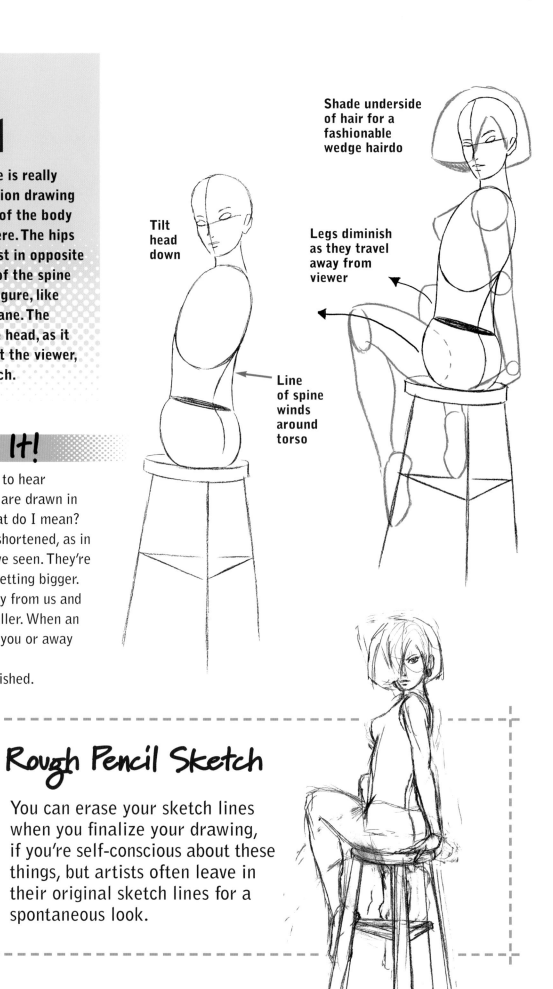

Tilt head down

Line of spine winds around torso

Shade underside of hair for a fashionable wedge hairdo

Legs diminish as they travel away from viewer

Rough Pencil Sketch

You can erase your sketch lines when you finalize your drawing, if you're self-conscious about these things, but artists often leave in their original sketch lines for a spontaneous look.

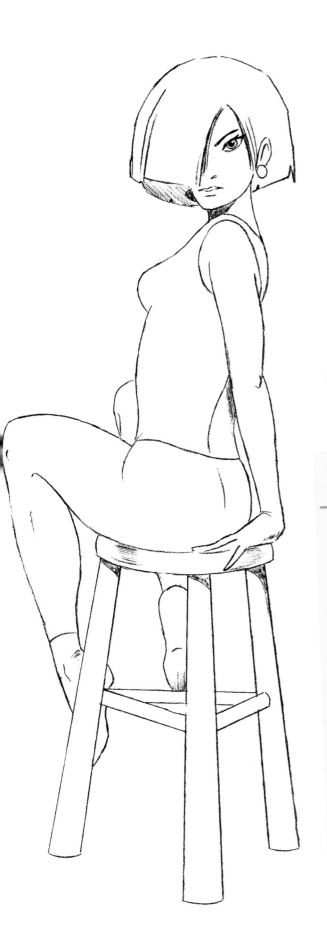

FYI

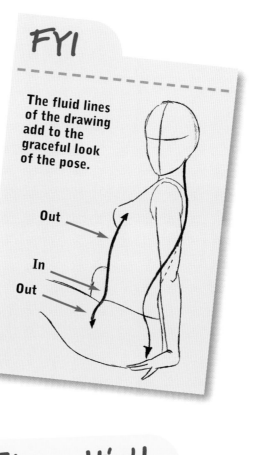

The fluid lines of the drawing add to the graceful look of the pose.

Out →

In →

Out →

Take a Hint!

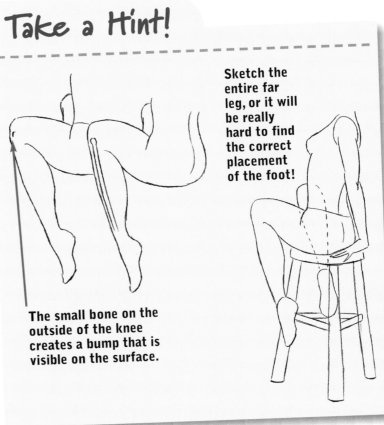

Sketch the entire far leg, or it will be really hard to find the correct placement of the foot!

The small bone on the outside of the knee creates a bump that is visible on the surface.

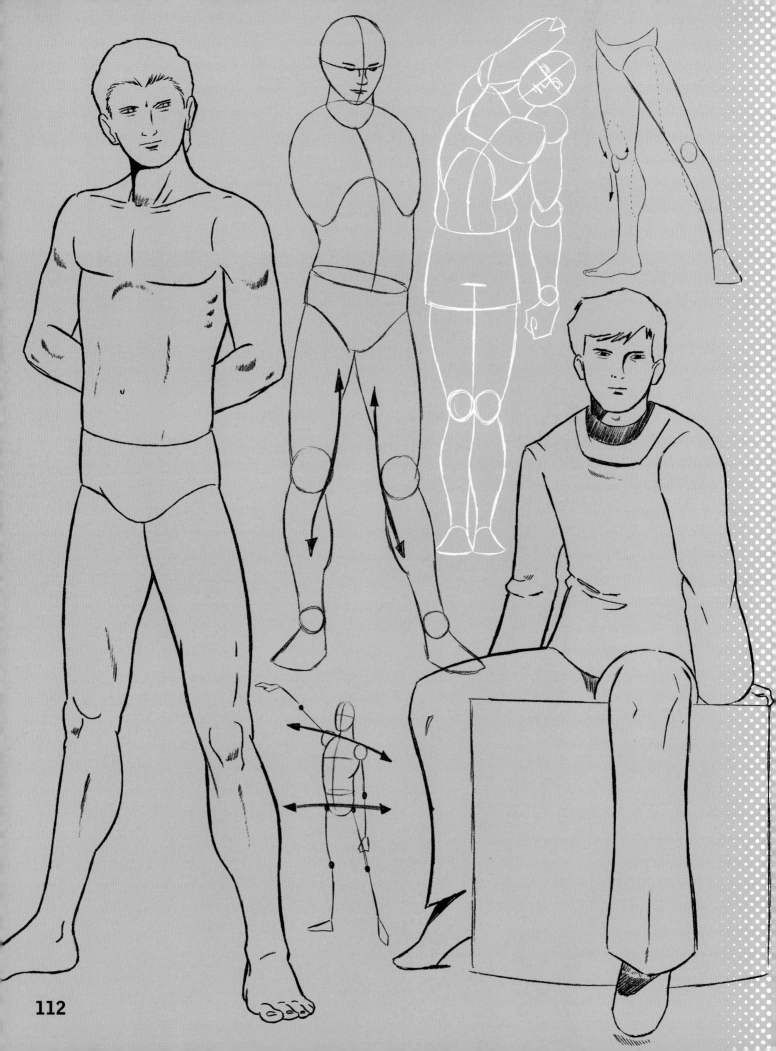

112

Get in Position!
Drawing Men

This chapter will focus more on rugged musculature than on the long, graceful lines we strove for with the female form. Of course, not all men work out at the gym. (I've actually heard that some are couch potatoes.) But generally, the muscles of the male physique are more developed and articulated on idealized figures and the poses are a little less flexible.

Classic Standing Pose

One of the main differences between female and male torsos evident in this simple standing pose is the waistline. On males, it's lower and not as pronounced. No hourglass figures here. And notice that the rib cage tends to be larger on men. There's just a look of more width overall.

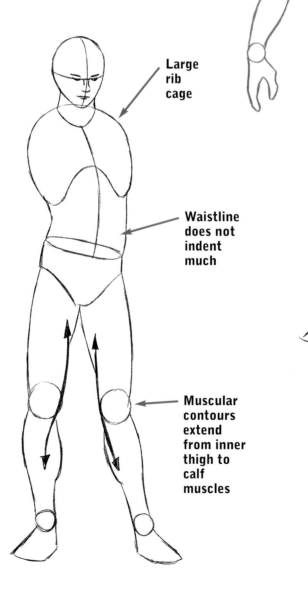

Wide shoulders

Large rib cage

Waistline does not indent much

Muscular contours extend from inner thigh to calf muscles

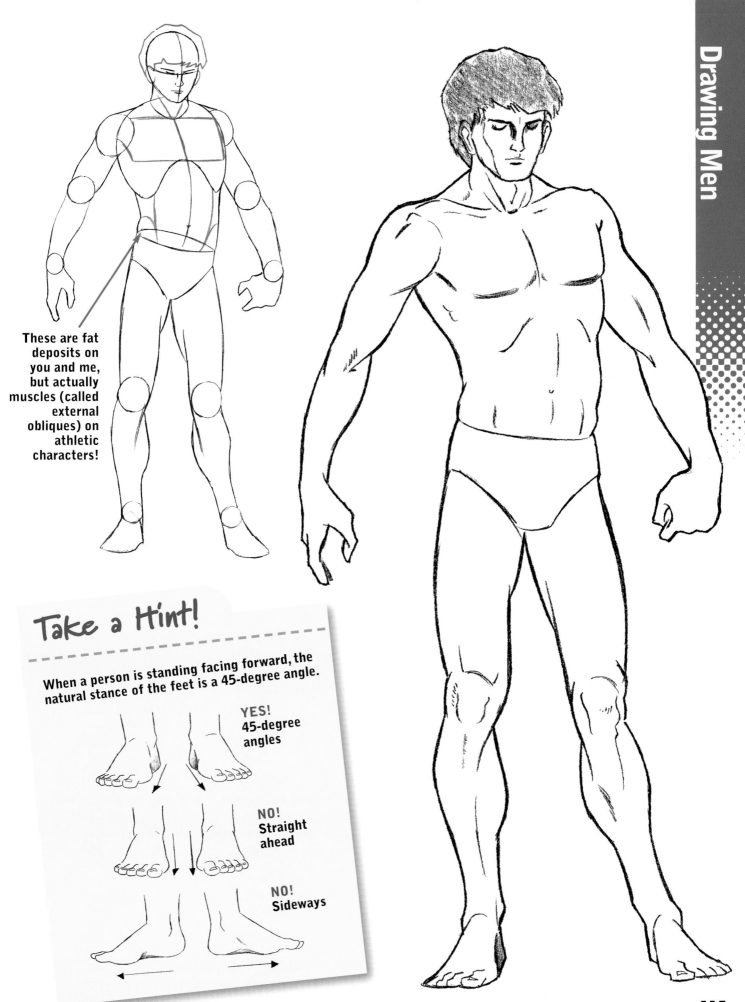

These are fat deposits on you and me, but actually muscles (called external obliques) on athletic characters!

Take a Hint!

When a person is standing facing forward, the natural stance of the feet is a 45-degree angle.

YES! 45-degree angles

NO! Straight ahead

NO! Sideways

115

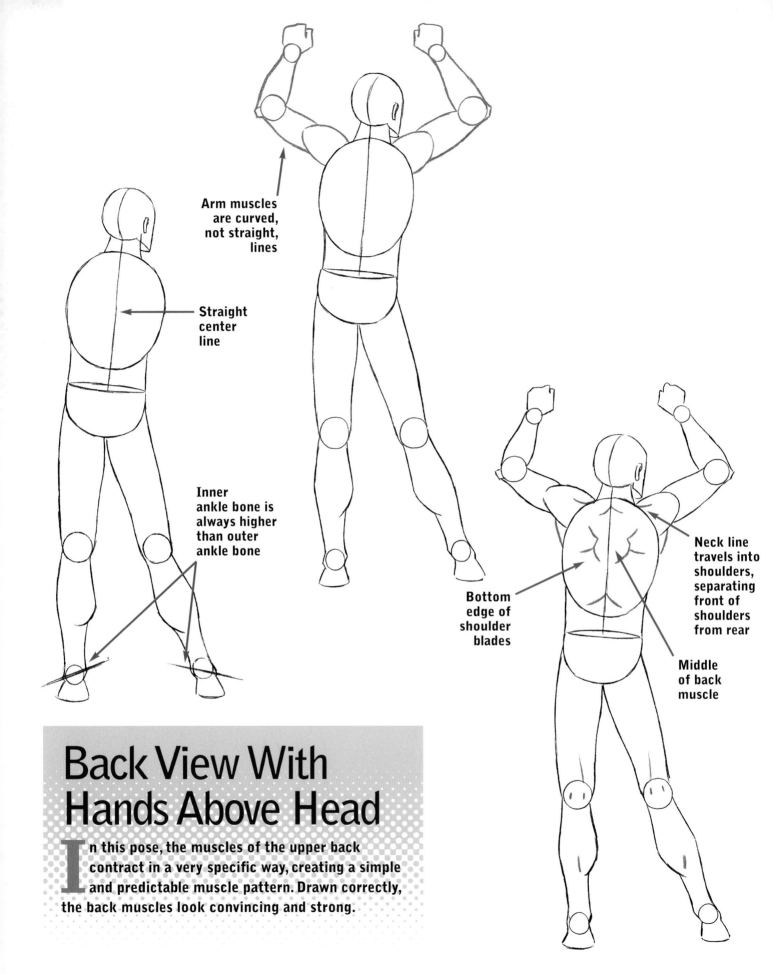

Arm muscles are curved, not straight, lines

Straight center line

Inner ankle bone is always higher than outer ankle bone

Neck line travels into shoulders, separating front of shoulders from rear

Middle of back muscle

Bottom edge of shoulder blades

Back View With Hands Above Head

In this pose, the muscles of the upper back contract in a very specific way, creating a simple and predictable muscle pattern. Drawn correctly, the back muscles look convincing and strong.

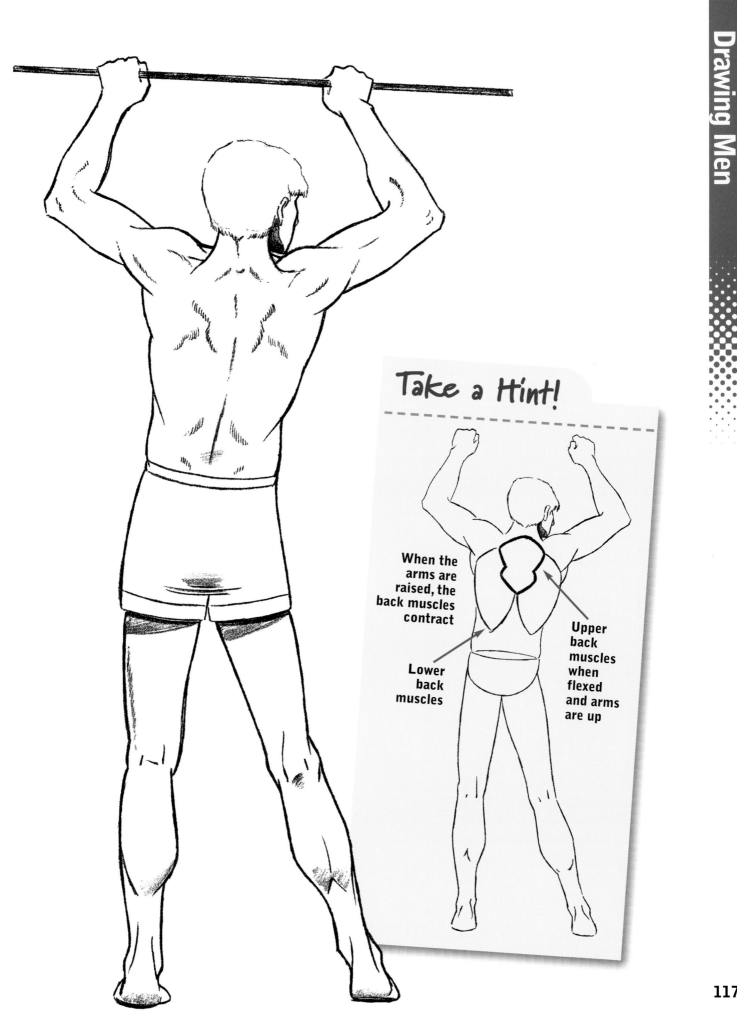

Take a Hint!

When the arms are raised, the back muscles contract

Lower back muscles

Upper back muscles when flexed and arms are up

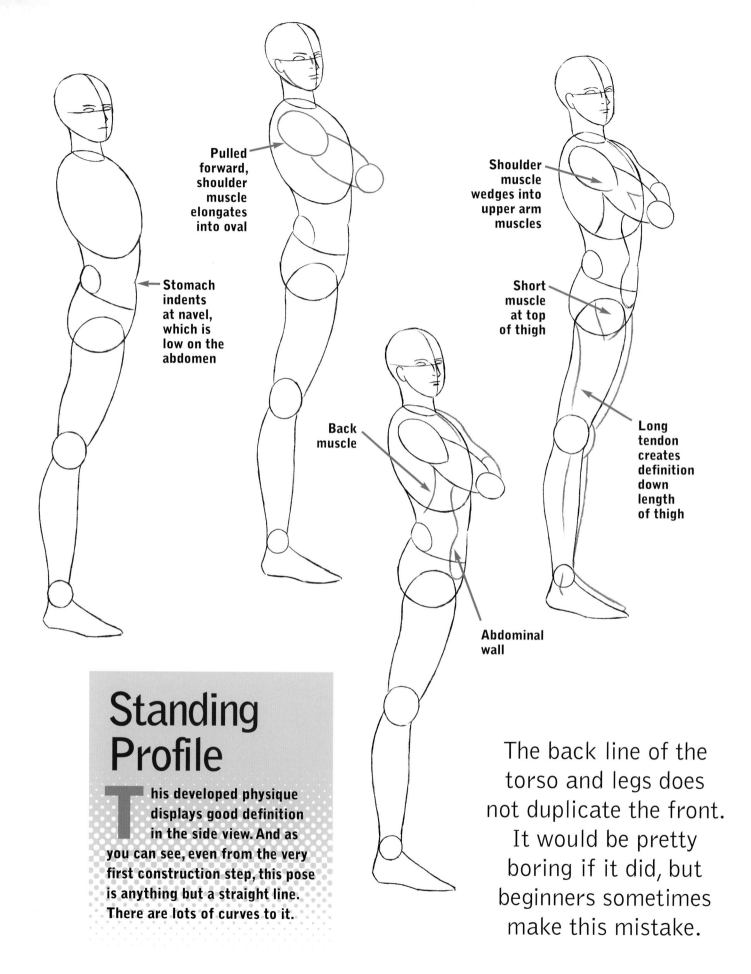

Pulled forward, shoulder muscle elongates into oval

← **Stomach indents at navel, which is low on the abdomen**

Shoulder muscle wedges into upper arm muscles

Short muscle at top of thigh

Long tendon creates definition down length of thigh

Back muscle

Abdominal wall

Standing Profile

This developed physique displays good definition in the side view. And as you can see, even from the very first construction step, this pose is anything but a straight line. There are lots of curves to it.

The back line of the torso and legs does not duplicate the front. It would be pretty boring if it did, but beginners sometimes make this mistake.

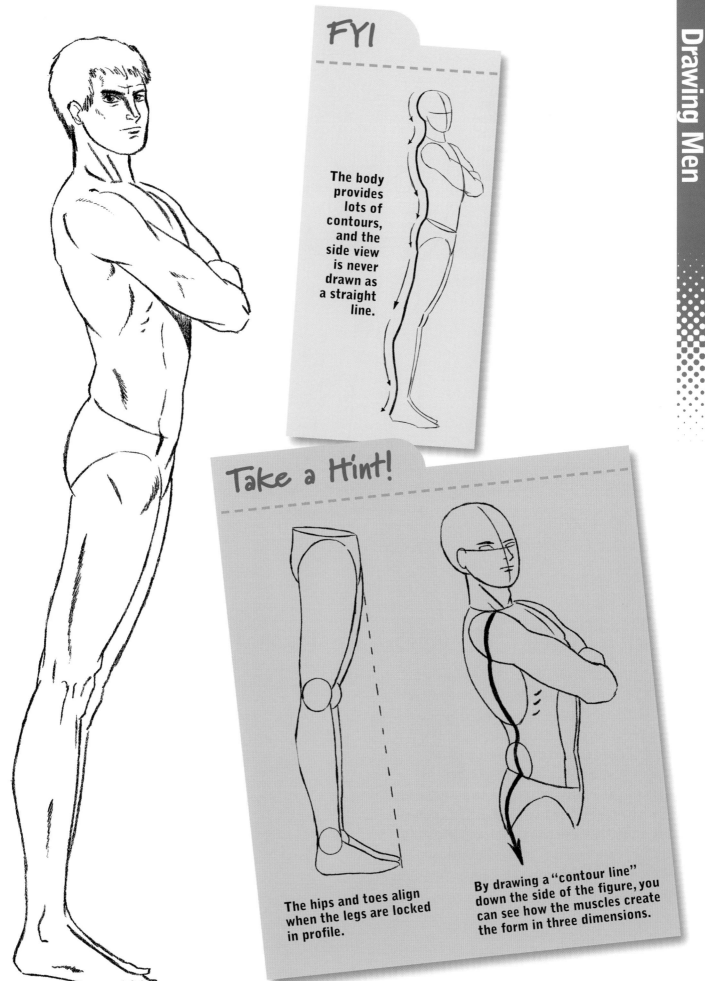

FYI

The body provides lots of contours, and the side view is never drawn as a straight line.

Take a Hint!

The hips and toes align when the legs are locked in profile.

By drawing a "contour line" down the side of the figure, you can see how the muscles create the form in three dimensions.

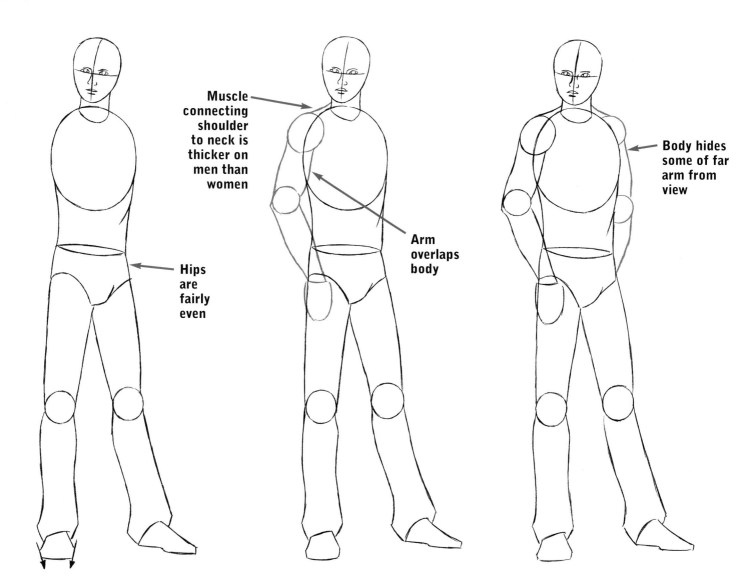

Muscle connecting shoulder to neck is thicker on men than women

Hips are fairly even

Arm overlaps body

Body hides some of far arm from view

Hands in Pockets

Another thing you'll discover, as we draw the male body and compare it to the female figures we've been drawing, is how it differs in terms of the hip and shoulder tilts. We've drawn a lot of women in which the hips tilt at a decent angle in one direction, and, to counterbalance, the shoulders tilt in the opposite direction. This gives the pose a lanky, pleasing quality. But the male figure is not as flexible, and although the same principles apply, they are more subtle.

Take a Hint!

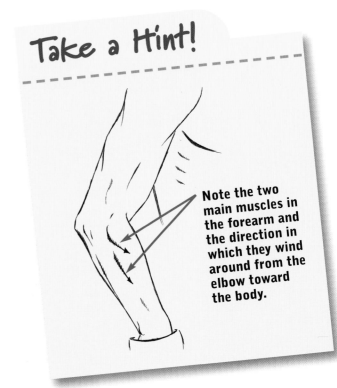

Note the two main muscles in the forearm and the direction in which they wind around from the elbow toward the body.

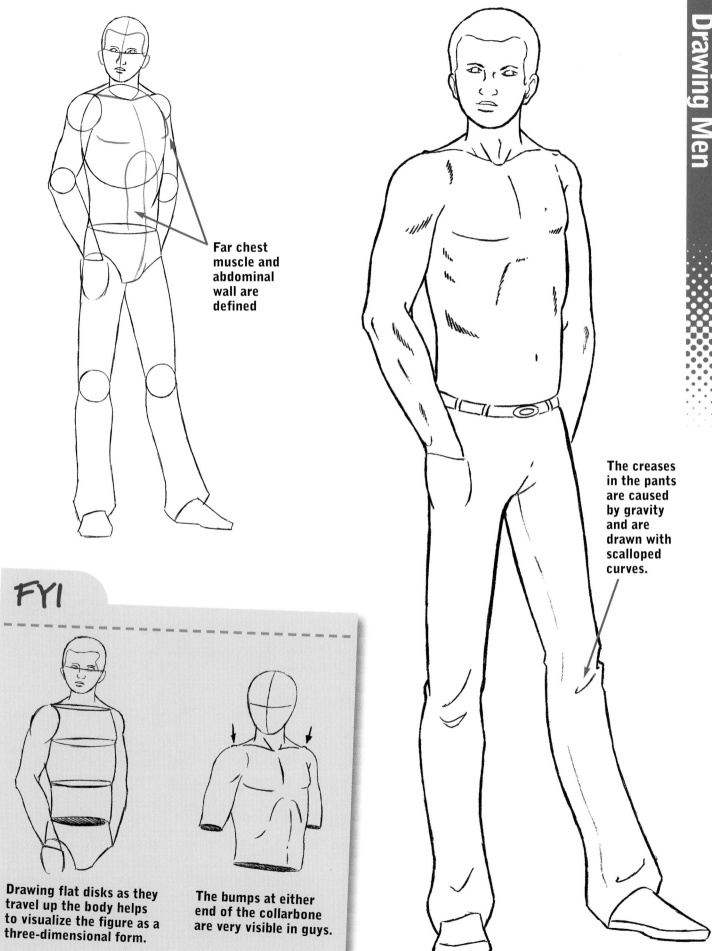

Far chest muscle and abdominal wall are defined

The creases in the pants are caused by gravity and are drawn with scalloped curves.

FYI

Drawing flat disks as they travel up the body helps to visualize the figure as a three-dimensional form.

The bumps at either end of the collarbone are very visible in guys.

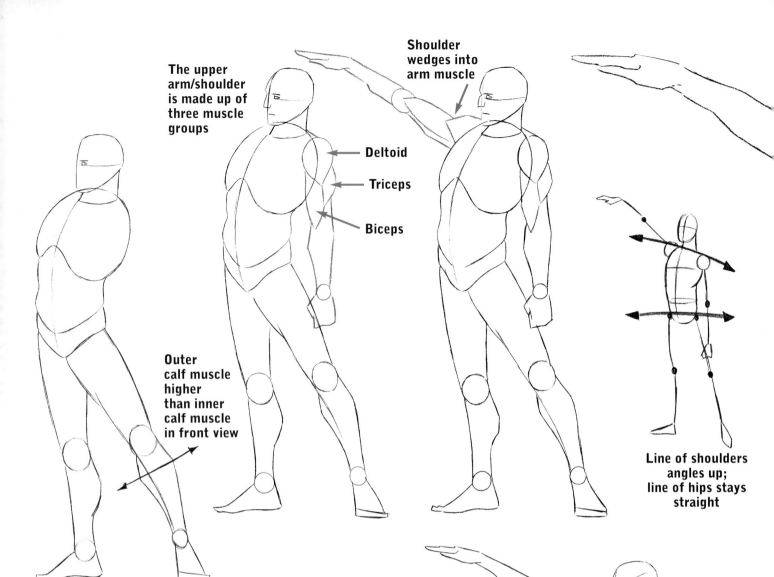

The upper arm/shoulder is made up of three muscle groups

Shoulder wedges into arm muscle

Deltoid

Triceps

Biceps

Outer calf muscle higher than inner calf muscle in front view

Line of shoulders angles up; line of hips stays straight

Heroic Pose

Here's a graceful male pose—drawn in a heroic manner. We'll call him "Captain Figure Model." Heroic figures have been drawn, painted and sculpted since the dawn of time. These days, there's a lot of demand for excellent figure-drawing work in commercial art, and comics now employ fine artists who really know how to portray heroic anatomy. When drawing an athletic character, define the muscles clearly.

Drawing a line from the top of the head to the chin helps to define the angles of the face.

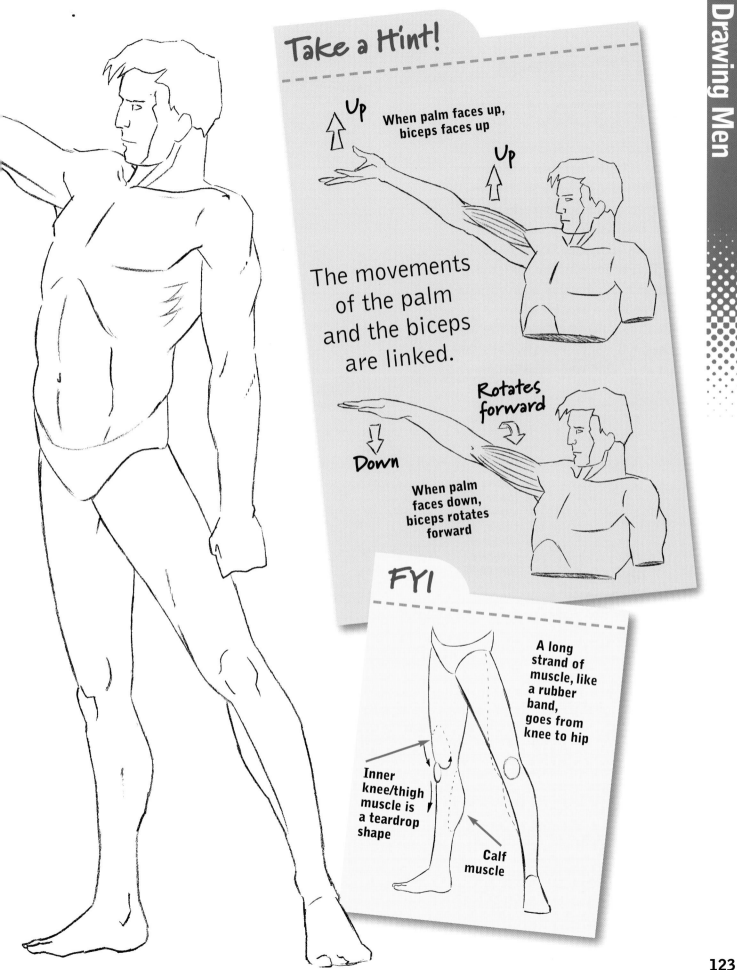

Take a Hint!

Up

When palm faces up, biceps faces up

Up

The movements of the palm and the biceps are linked.

Rotates forward

Down

When palm faces down, biceps rotates forward

FYI

A long strand of muscle, like a rubber band, goes from knee to hip

Inner knee/thigh muscle is a teardrop shape

Calf muscle

Seated Pose in Perspective

Look at how compressed that near leg is. That's because it is facing us directly, so it has to flatten out completely. Total foreshortening. It sounds impossible, I know, but it's all about the technique. Many of us assume that to foreshorten something correctly is a complicated and intricate process. No, it is a process of simplification. And counterintuitive as it may seem, it's actually easy. Let's take a whack at it, shall we?

FYI

Don't sit your figure up completely straight, or he'll look stiff and unnatural.

WRONG! Too stiff

RIGHT! Leaning slightly forward

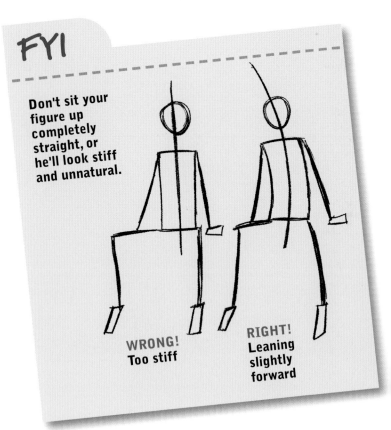

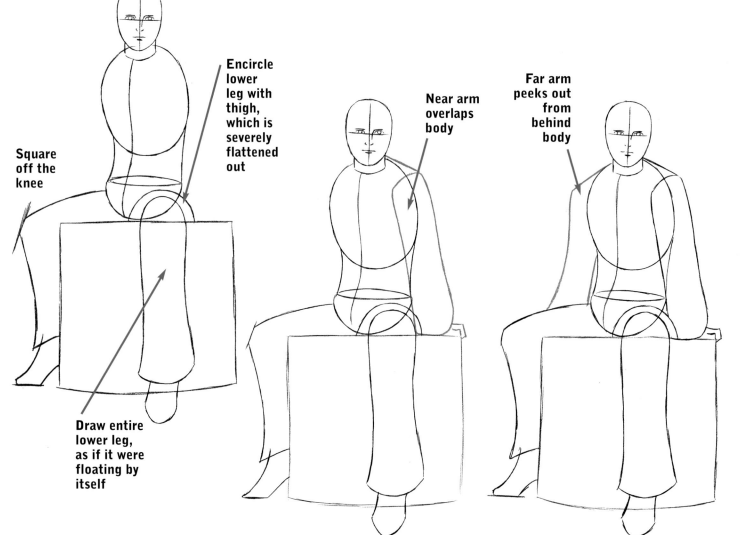

Square off the knee

Encircle lower leg with thigh, which is severely flattened out

Draw entire lower leg, as if it were floating by itself

Near arm overlaps body

Far arm peeks out from behind body

124

Take a Hint!

Note the angles of the legs in this seated pose.

Line of leg is not straight, but curves down

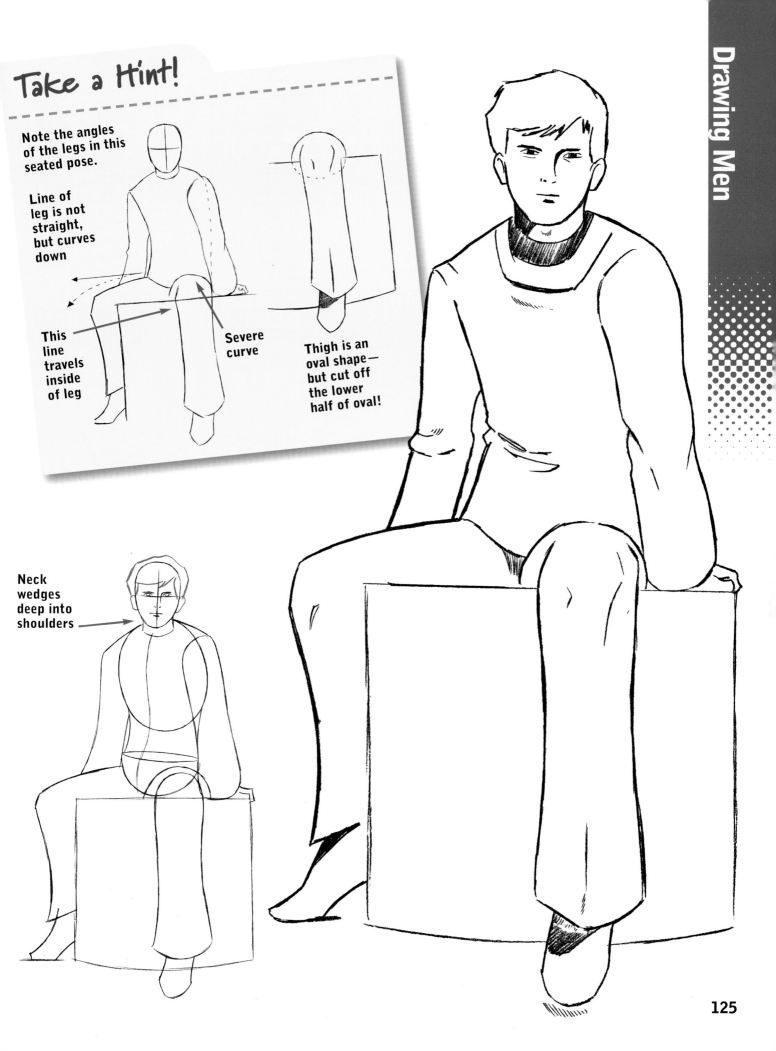

This line travels inside of leg

Severe curve

Thigh is an oval shape— but cut off the lower half of oval!

Neck wedges deep into shoulders

Standing With Hands Behind Body

In this sturdy yet relaxed pose, the trunk is quite straight, and we can see the lines of the abdominal wall meld with the rib cage. The shoulders are well formed and intersect with the chest muscles. The near leg offers a front view of the knee, while the far leg displays a side view. Note that even on an athletic character such as this one, the waist, which is narrow, doesn't indent that much. That's a more feminine characteristic.

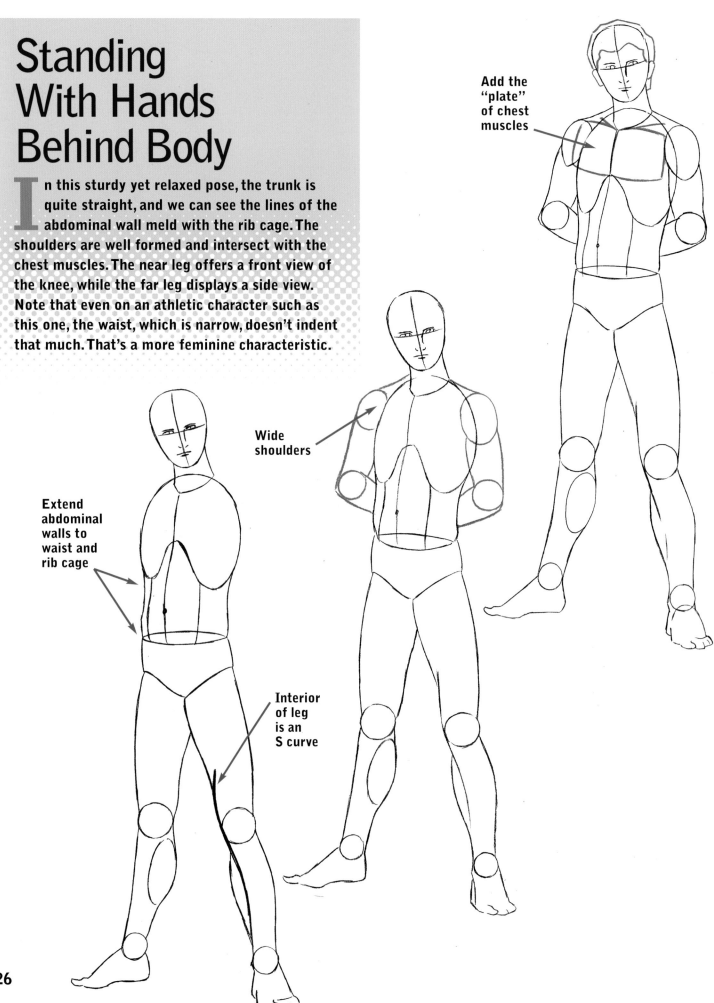

Add the "plate" of chest muscles

Wide shoulders

Extend abdominal walls to waist and rib cage

Interior of leg is an S curve

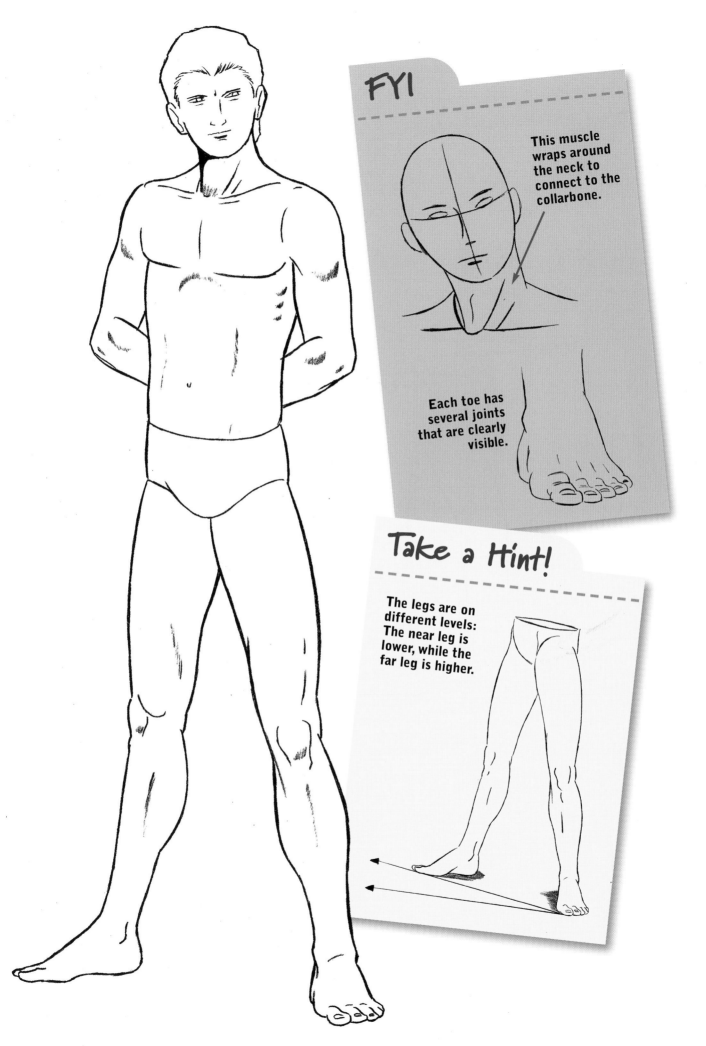

FYI

This muscle wraps around the neck to connect to the collarbone.

Each toe has several joints that are clearly visible.

Take a Hint!

The legs are on different levels: The near leg is lower, while the far leg is higher.

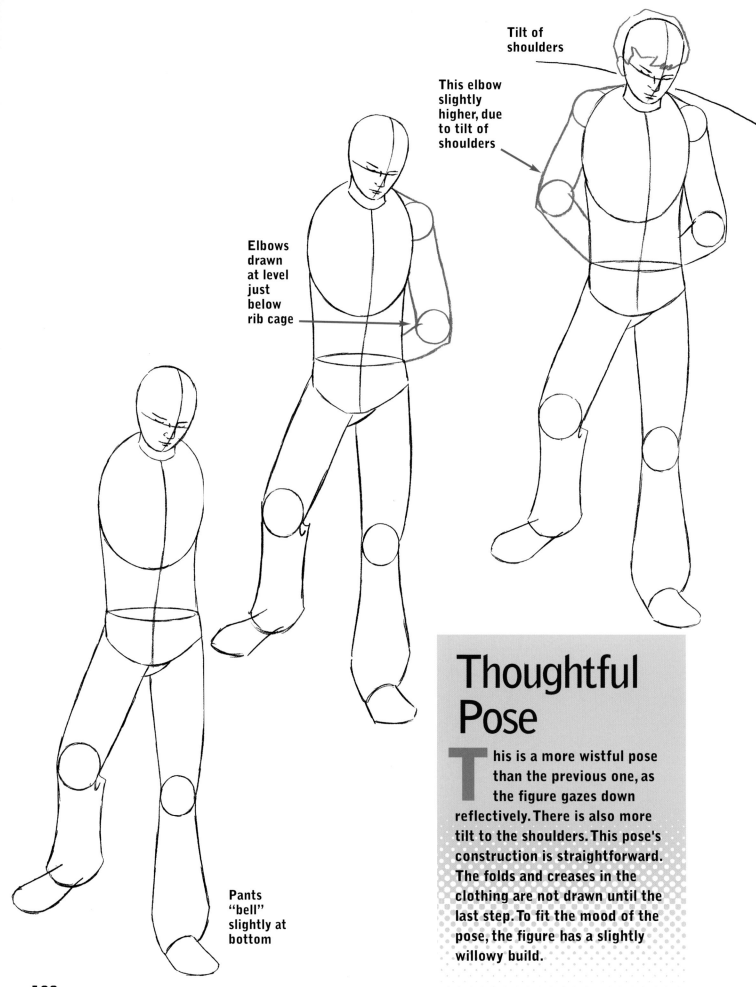

Tilt of
shoulders

This elbow
slightly
higher, due
to tilt of
shoulders

Elbows
drawn
at level
just
below
rib cage

Pants
"bell"
slightly at
bottom

Thoughtful Pose

This is a more wistful pose than the previous one, as the figure gazes down reflectively. There is also more tilt to the shoulders. This pose's construction is straightforward. The folds and creases in the clothing are not drawn until the last step. To fit the mood of the pose, the figure has a slightly willowy build.

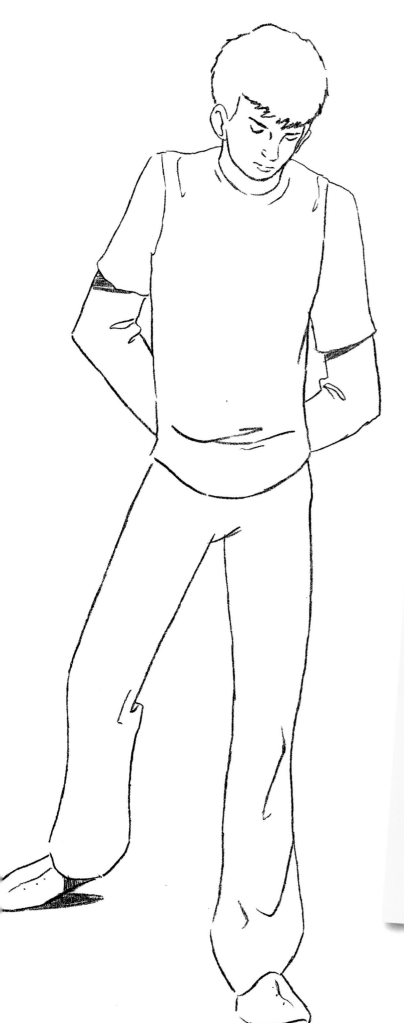

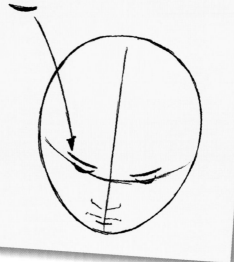

Take a Hint!

The eyebrows curve down when the head faces front and up when the head looks down.

Looking ahead—eyebrows curve down

Looking down—eyebrows curve up

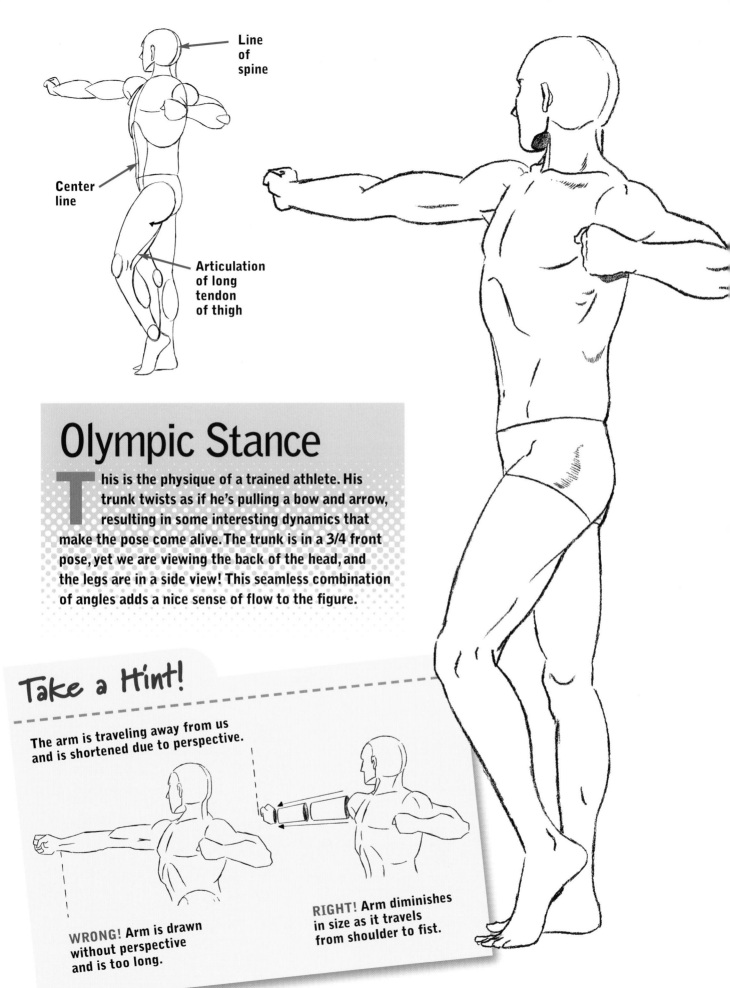

Line of spine

Center line

Articulation of long tendon of thigh

Olympic Stance

This is the physique of a trained athlete. His trunk twists as if he's pulling a bow and arrow, resulting in some interesting dynamics that make the pose come alive. The trunk is in a 3/4 front pose, yet we are viewing the back of the head, and the legs are in a side view! This seamless combination of angles adds a nice sense of flow to the figure.

Take a Hint!

The arm is traveling away from us and is shortened due to perspective.

WRONG! Arm is drawn without perspective and is too long.

RIGHT! Arm diminishes in size as it travels from shoulder to fist.

Bend and Stretch

When an athlete bends, his muscles are even more apparent, because all that physical training has caused them to define themselves into sections, and bending stresses them. Aim to blend one muscle group into another so that they flow pleasingly. In this pose, the stress point—where the most bending takes place—is just above the waistline, because that's the spot where there is no bone.

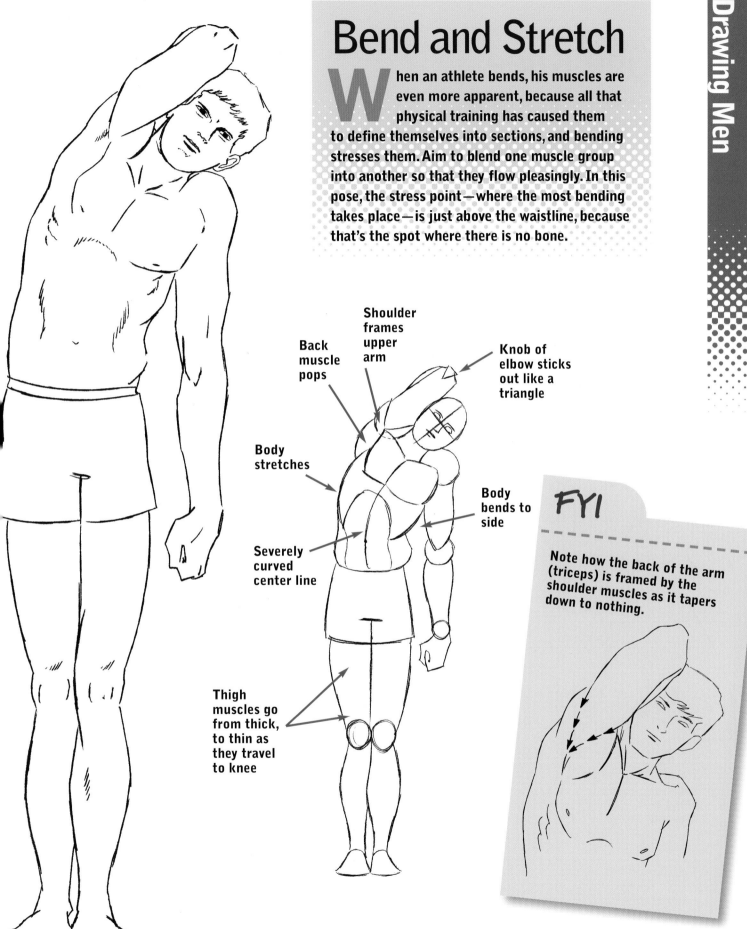

Back muscle pops

Shoulder frames upper arm

Knob of elbow sticks out like a triangle

Body stretches

Body bends to side

Severely curved center line

Thigh muscles go from thick, to thin as they travel to knee

FYI

Note how the back of the arm (triceps) is framed by the shoulder muscles as it tapers down to nothing.

On One Knee

Both knees in this picture are drawn in perspective, because the nearer leg is coming at you and the far leg is traveling away. The trick in creating a foreshortened limb, like the near leg, is to simplify it. This enables the eye to take it in at a glance. You may be tempted to make it more complicated, as if that will communicate a greater understanding of the mechanics. But that rarely improves the drawing.

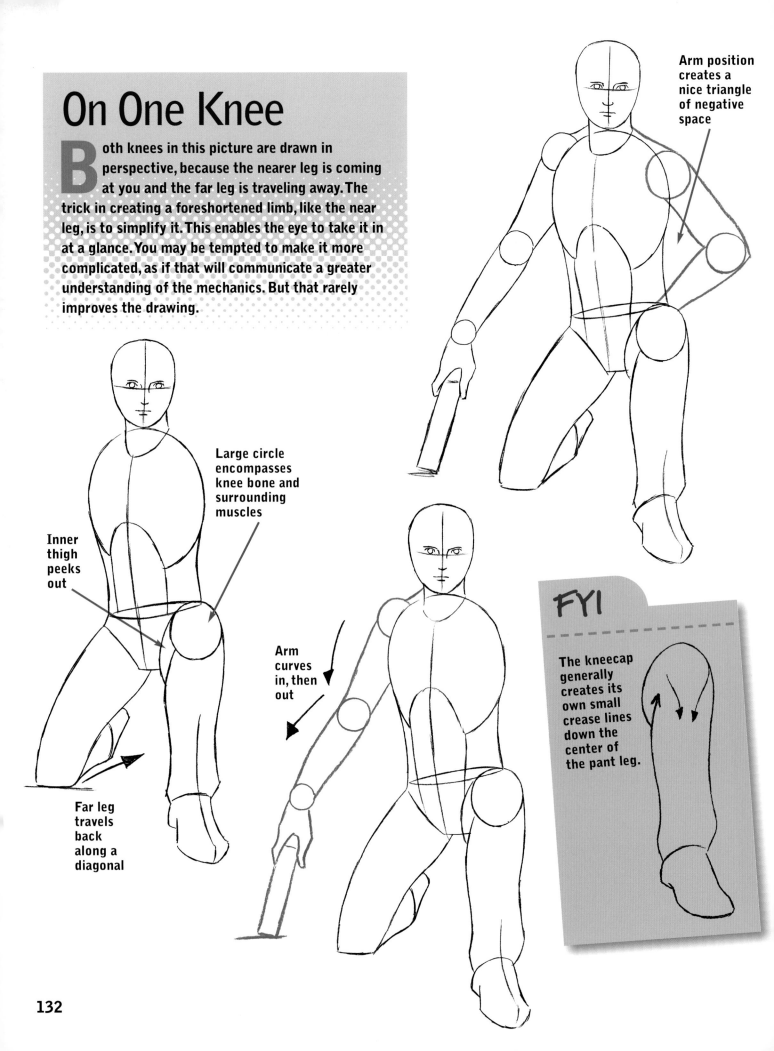

Arm position creates a nice triangle of negative space

Large circle encompasses knee bone and surrounding muscles

Inner thigh peeks out

Far leg travels back along a diagonal

Arm curves in, then out

FYI

The kneecap generally creates its own small crease lines down the center of the pant leg.

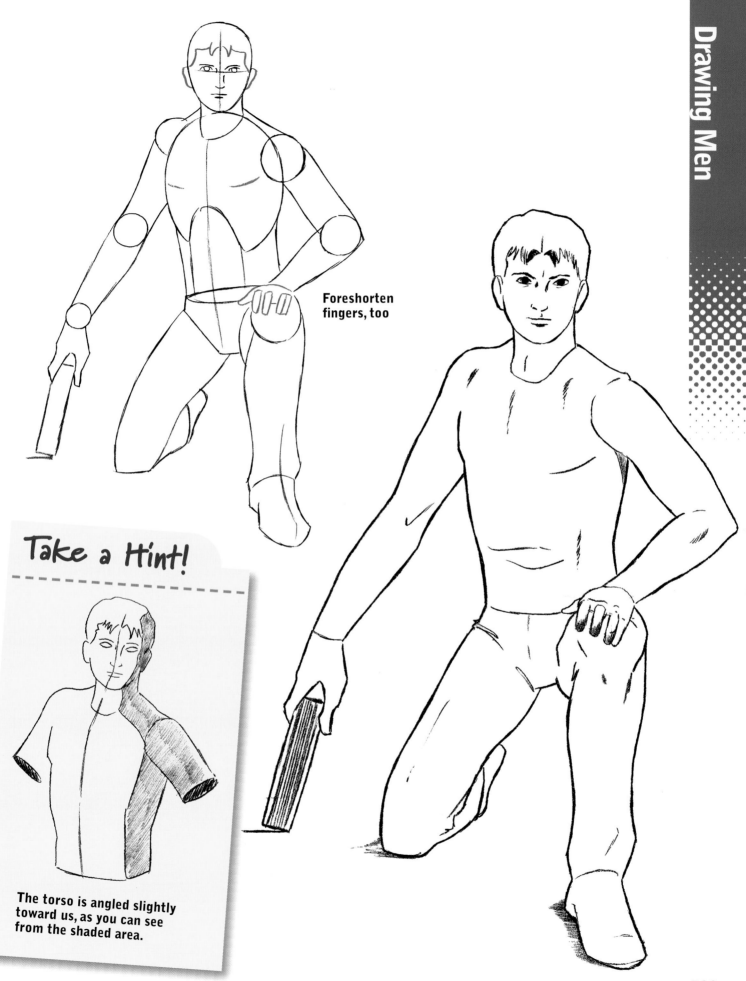

Foreshorten fingers, too

Take a Hint!

The torso is angled slightly toward us, as you can see from the shaded area.

Muscle Interaction

Pushing the shoulders together has the effect of bunching the chest muscles (pectoralis major) together and making them appear narrower. In this pose, the shoulders (deltoids) come toward the front of the torso, causing the muscles that connects the neck and back (the trapezius muscles) to bunch up as well. That's how the body works: Flexed muscles often affect surrounding muscle groups.

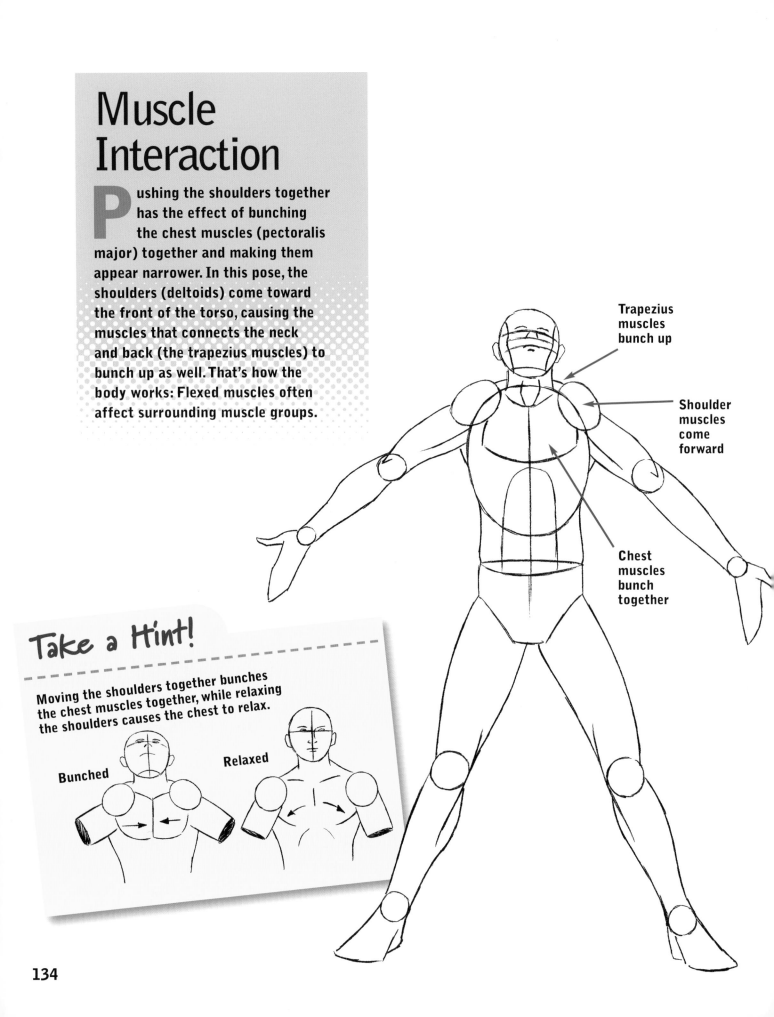

Trapezius muscles bunch up

Shoulder muscles come forward

Chest muscles bunch together

Take a Hint!

Moving the shoulders together bunches the chest muscles together, while relaxing the shoulders causes the chest to relax.

Bunched

Relaxed

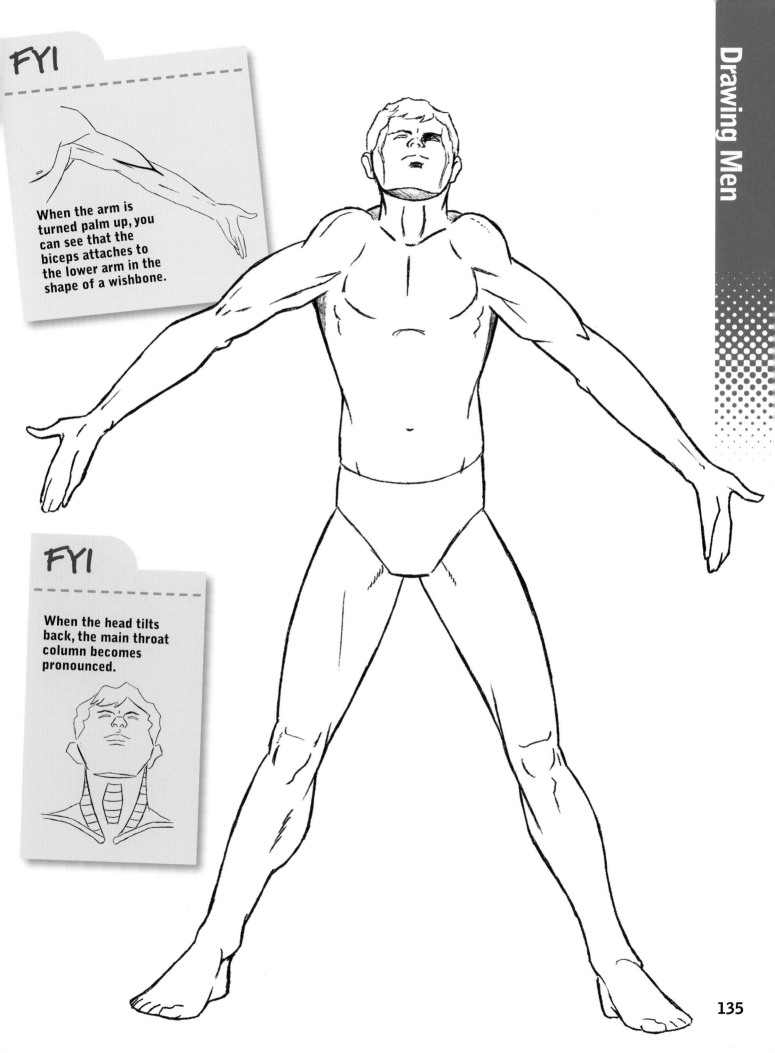

FYI

When the arm is turned palm up, you can see that the biceps attaches to the lower arm in the shape of a wishbone.

FYI

When the head tilts back, the main throat column becomes pronounced.

Standing With Arms Out (Side View)

I always like the visual effect of a pose like this: It starts with a side view at the waist, but as it travels upward, the body twists, with the spine as its focus, winding around into almost a 3/4 view as it reaches the upper back. This adds some depth and drama to what would otherwise be a flat profile.

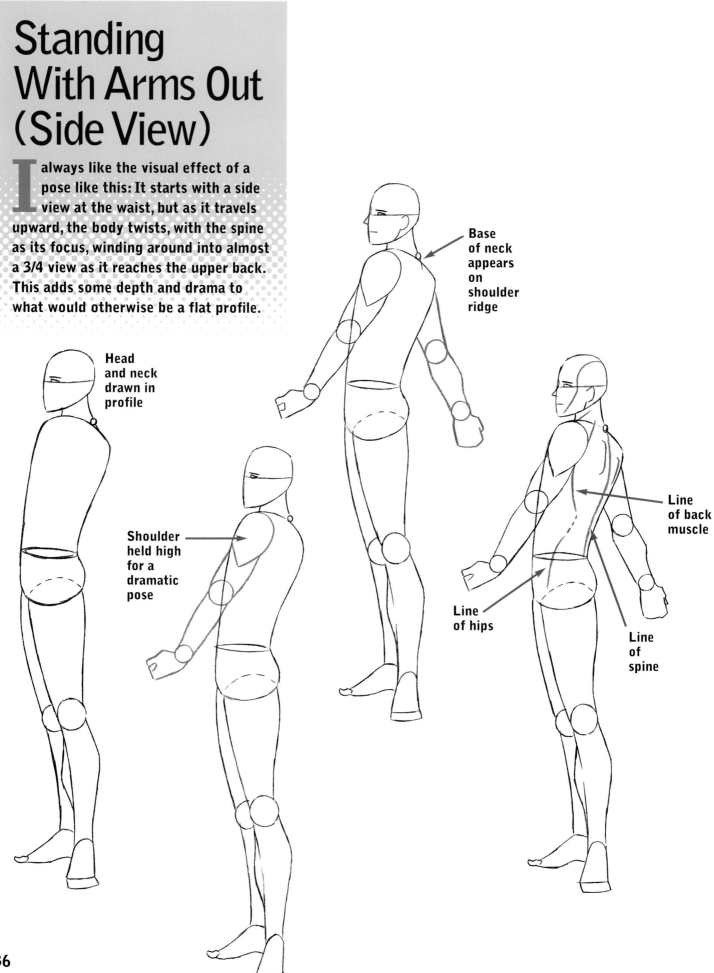

Base of neck appears on shoulder ridge

Head and neck drawn in profile

Shoulder held high for a dramatic pose

Line of back muscle

Line of hips

Line of spine

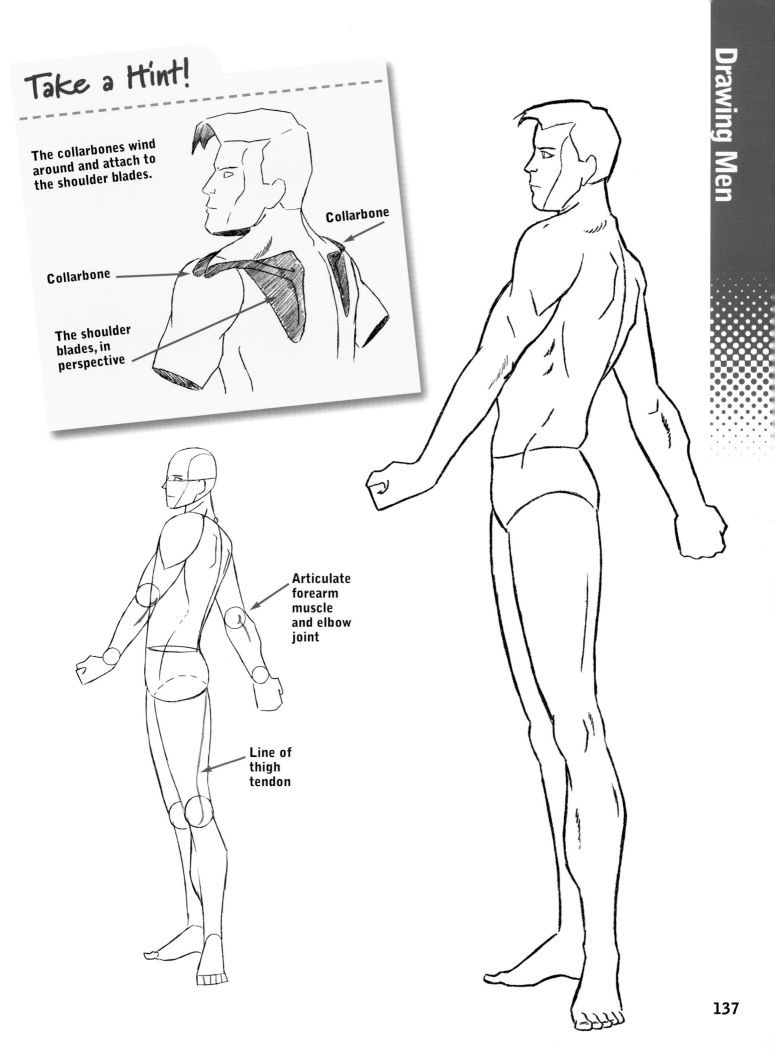

Take a Hint!

The collarbones wind around and attach to the shoulder blades.

Collarbone

Collarbone

The shoulder blades, in perspective

Articulate forearm muscle and elbow joint

Line of thigh tendon

Relaxed Figure (Side View)

Here we have a strict side pose without depth. But we give it some life by using hip tilt. The weight-bearing leg—the straight one nearest to us—pushes up the hip, and as a result, the clothing gathers near the waistline on our side. As a counterbalance, the near shoulder dips down.

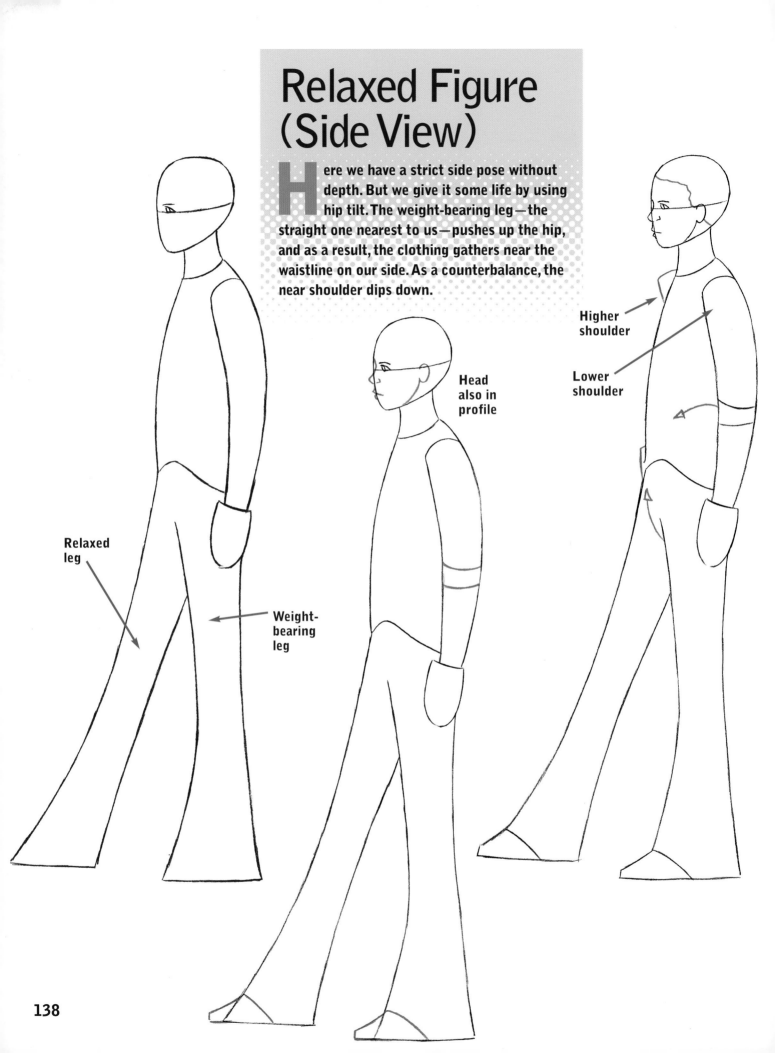

Head also in profile

Higher shoulder

Lower shoulder

Relaxed leg

Weight-bearing leg

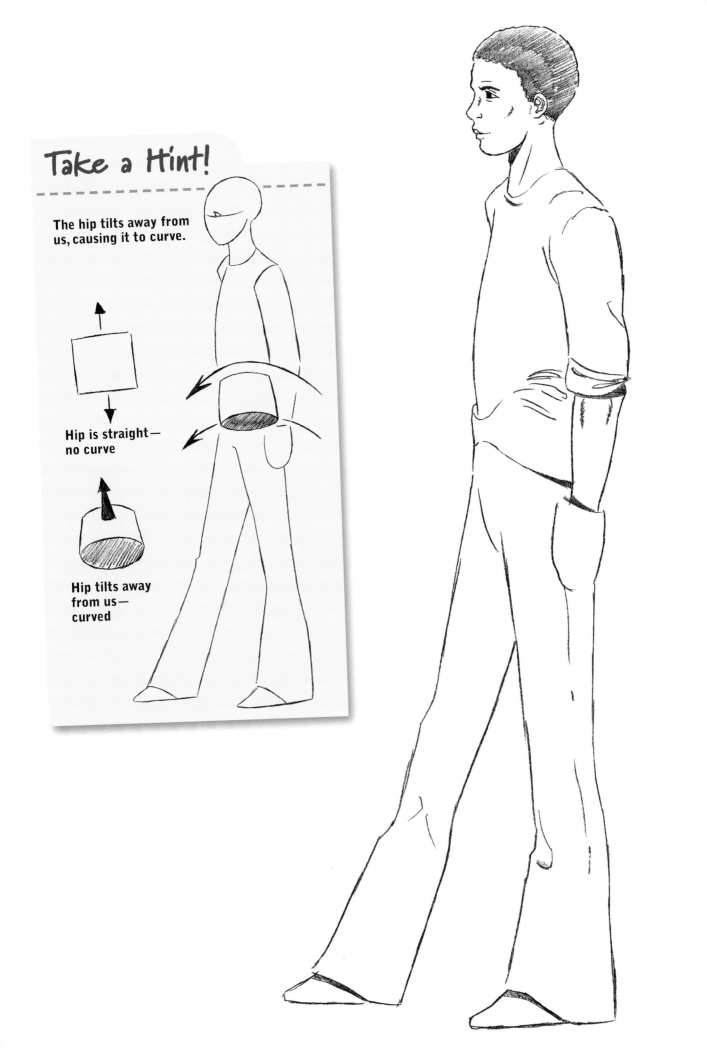

Take a Hint!

The hip tilts away from us, causing it to curve.

Hip is straight—
no curve

Hip tilts away
from us—
curved